To really appreciate what makes Newport such a special city, one needs to understand the unique role that Newport played in the Gilded Age of America. In this book, author Ed Morris has done a fine job of presenting us with a short but intriguing glimpse into the grand palaces of Newport and the fascinating people who built them.

I would encourage any visitor to Newport to use this book as a self-guided tour of the Cliff Walk. It will give you an appreciation of the marvelous architectural details and colorful family histories associated with many of these great homes.

I sincerely hope that you enjoy your visit to Newport. Regardless of whether you have journeyed here for business or for vacation, I highly recommend that you take the time to explore and experience the Cliff Walk. It is a travel treasure not to be missed. As a guest in our city, please be respectful of this special place and the residents who live here. Thank you.

Newport welcomes you.

—Evan Smith,
President & CEO,
Newport County Convention & Visitors Bureau

A lively anecdotal tour of the historic confines of Newport's Cliff Walk. Ed Morris successfully details and conveys the essence of lifestyle within the cottages and the logic behind their construction. A great primer on Gilded Age Newport.

—Paul Miller, Curator,
Preservation Society of Newport County

A GUIDE TO Newport's CLIFF WALK

TALES OF SEASIDE MANSIONS & THE GILDED AGE ELITE

ED MORRIS

Charleston London

THE
History
PRESS

Published by The History Press
Charleston, SC 29403
www.historypress.net

First published 2009
Second printing 2011
Third printing 2011
Fourth printing 2013

Manufactured in the United States

ISBN 978.1.59629.438.7
Library of Congress Cataloging-in-Publication Data
Morris, Ed.
A guide to Newport's Cliff Walk : tales of seaside mansions and the gilded age
elite / Ed Morris.
p. cm.
Includes bibliographical references.
ISBN 978-1-59629-438-7
1. Newport (R.I.)--Guidebooks. 2. Newport (R.I.)--History. 3. Walking--Rhode
Island--Newport--Guidebooks. I. Title.
F89.N5M792 2009
917.45'7--dc22
20080486

To my wife, Jane, and my son, Robert, for their patient support, criticisms and opinions in writing this guide to Newport's Cliff Walk with its mirrorlike reflections of the period that Mark Twain so aptly christened the Gilded Age.

Cliff Walk

Aquidneck Island, in Rhode Island's Ocean State, hosts a
 trail beside the sea

Where on Newport's legendary cliff walk fog-shrouded
 mansions rise in mystery.

Above the Atlantic's pounding rage one walks past treasures
 from another age

To glimpse grand palaces on a fabled path along a precipice
 above the ocean's wrath,

As ghostly mists from another time enshroud the visitor
 within the sublime,

To view gray sentinels that echo times of lore from the
 Gilded Age, that lavish life before,

When Newport was but America's social queen, of an
 opulence our nation has seldom seen.

Many mansions there, yet, now do last, those triumphant
 reminders of the past,

Where, by moonlight, lofty chimneys yet silhouette the sky
 above cliffs and rocks over the ocean's haunting sigh.

Above the gray cliffs, those do yet dwell, who recall legends
 of the cliff walk's many tales to tell

Of gossip and social scandals and tragedies of the sea, of
 success and failure during Newport's proud history.

—Alfred Richardson Simson

CONTENTS

Contents

PREFACE

When I came to Newport as a retired journalist several years ago, I had vague hopes of refining my knowledge of my family's links to my sixth great-grandfather, Captain Richard Morris—a mercenary who, with his son-in-law John Underhill, accompanied Governor John Winthrop aboard the *Arbella* in the 1630 founding of the Massachusetts Bay Colony. In 1638, my ancestors were banished for their support of Anne Hutchinson's so-called Antinomian heresy. They settled in Portsmouth, Rhode Island (then known as Pocasset), and soon after, in Newport. I did learn that Captain Morris became a Newport freeman (with the right to vote as a property owner) in 1641; was paid six pounds, five shillings to serve as the state general assembly's treaty representative to Connecticut in 1665; and was reimbursed ten pounds in 1667 for candles and fuel he provided during general court sessions held in the great room of his house over the previous five years. Records show that these reimbursements continued until at least 1674. I also learned that, in 1672, a petition was granted to Mrs. Morris to set aside a whipping sentence of her granddaughter, Mary

Stokes, "for adultery" if she paid five pounds. So much for researching one's ancestors! Researching Cliff Walk seemed like a better idea. After getting my BA in German literature from Connecticut's Wesleyan University, I spent three years in the Army Security Agency deciphering codes of East German PT boats. My journalistic career began when I took a job as a copy boy for the *New York Enquirer* before its publisher renamed it the *National Enquirer*. At that point, the paper's circulation rose from sixty thousand into the multimillions, and its staff changed from old-time newshawks to highly paid sleuths.

My marriage to a brilliant and beautiful British medical secretary to Flower Hospital's chief of psychiatry fueled my ambition to become a foreign news correspondent. My first stint was in Germany as a reporter for a trade publication, *Made in Europe*. After that, I worked for the American serviceman's newspaper the *Overseas Weekly*, where I covered some one hundred general court-martials; an anticommunist publication, *Tarantula Press*; and, finally, the Berlin Bureau of the United Press International newswire service during the time before the new Great Wall of the Communists ended the flood of refugees from East Germany.

My son Robert's educational needs—among other things— brought us back to Connecticut, where I reported first for the *New Haven Register*, then the travel publication *Travel Weekly* and, finally, the *Bridgeport Post*. A midlife correction brought me into the world of stock and real estate speculation and then to postretirement jobs such as this *Guide to Newport's Cliff Walk* and its reflection of the Gilded Age.

ACKNOWLEDGEMENTS

I am very much indebted to the Newport Historical Society—especially to Pieter Roos, education director, and Daniel Snydacker, executive director—for advice and suggestions in my research and for encouraging me to compose a Cliff Walk guide's script (which I have expanded into the present book), but also for allowing me to serve as the society's guide for Cliff Walk tour groups for six summers.

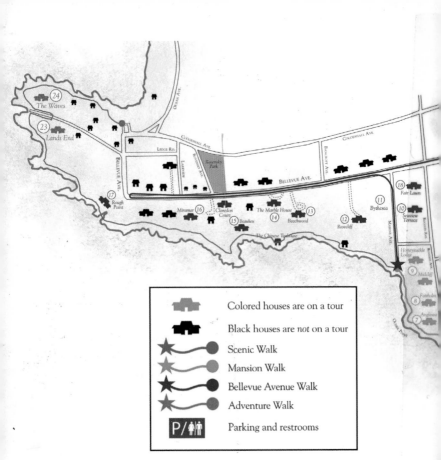

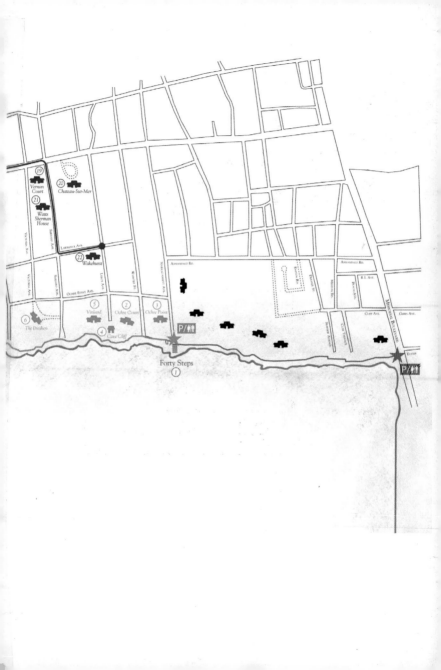

INTRODUCTION

Cliff Walk most probably began as an Indian trail along Newport's ocean cliffs. It was a place for "tea and romping" in colonial times and functioned as a public path through sheep pastures in the middle of the nineteenth century. At the turn of the century, it was, as it stands today, a manicured right of way, sunken below eye level for the privacy of the great high society parties held in Gilded Age palaces.

Just as the computer, fax, cellphone and endless other types of automation are creating massive changes in the nature and ways of achieving wealth in our own time, the nineteenth century had its own set of innovations. The invention of the fire-tube railway locomotive boiler in 1829; the oil well in 1859; the typewriter in 1867; the telephone in 1876; the incandescent electric light in 1879; the linotype press in 1884; the electric transformer in 1885; the alternating current electric generator and motor in 1892; the wireless radio in 1895; the safety razor in 1901; and the airplane in 1903 are just a few of the many events that had an impact on our society and culture.

As the whirlwind of the American Industrial Revolution forever changed our agrarian economy, the railroads opened

land that had been inaccessible by river and slow overland wagon trails. Immigrants poured into our make-it-on-your-own economy, and a great new wealthy class emerged. More than five hundred marriages took place from 1880 to World War I between the children of the American nouveau riche and British and European nobility, with a total estimated dowry of more than $220 million (over $3 billion in today's dollars).

The cultural veneer of the new money class grew with the generations. Old Commodore Vanderbilt could sell his fleet of steamships, sail a new steam yacht to Europe and meet with the lord mayor of London and the admiral of the Russian fleet in St. Petersburg, but he cursed a bluer streak than the barge captains and liked to pinch his hostesses on the rear. It was his grandsons who were educated and his granddaughter-in-law who broke down the social barriers to their family.

The men of this era built the palaces in which the social queens reigned, but they kept to their own private clubs. Women set the new social rules and governed armies of household staff, who were dressed like attendants in European palaces. The United States was emerging as a new world power, but these ladies were emerging as emancipated women—divorce became acceptable, as did multimillion-dollar divorce settlements and the right to own property.

There was a striving for greatness during the Gilded Age: in wealth, palaces and fashion, but also in architecture, painting, sculpture, music and literature. These were the new Medici, and they were ready to play their part as patrons. This book

will introduce the great Gilded Age architectural works that lie along Cliff Walk and tell about the lives and fortunes of the patrons who lived in them. Some of the stories included are anecdotal and probably impossible to verify. Others may even be considered apocryphal but are included to illustrate the characters involved. The Cliff Walk tour, whether taken with myself or this book as your guide, will be rather like traveling in time back to the Gilded Age, when villains and heroes seemed to be larger than life.

Take, for instance, the Erie Railroad stock wars between Commodore Vanderbilt, the treacherous Daniel Drew, slippery Jim Fisk (shot by his business partner on the steps of a New York hotel) and the manipulative Jay Gould, who the fierce and frosty commodore called "too slick to handle." And then there were architectural geniuses like Stanford White— so brilliant, so fun loving, yet each with his own tragic flaw. White, a man who "could love a thousand girls," was shot on the roof garden of his great creation, New York's original Madison Square Garden building, setting the stage for what was potentially the most sensational murder trial in twentieth-century journalism.

Cliff Walk stretches about 3.5 miles and can be divided into several sections. Sections II and III, as outlined in this guide, cover the part of Cliff Walk where the mansions are most clearly visible, while Sections I and IV cover the north and south ends of Cliff Walk, which were sunken for privacy. Please keep in mind that the terrain of the most southern portion of the walk becomes hazardous, unless you are a climber.

This book is based on the tour guide's script and includes additional historical material. However, much more could be said about the fascinating people touched on in these pages. As it is, I can give you no more than crumbs from our history in order to hold this book to a reasonable size. I do hope you will relish these crumbs.

SCENIC WALK

Starting on Memorial Boulevard at Easton's Beach (called "the Common Beach" in Gilded Age times) and heading south along the shore, you will find a smooth walking path, beautiful water views, rocky cliffs, trees and vegetation but no glimpses of fabled architectural mansions above you. If you are more interested in viewing the mansions along Cliff Walk and wish to conserve time, you may alternatively park on Narragansett Avenue and begin your tour at the Forty Steps.

This first section of Cliff Walk runs 0.7 miles from Easton's Beach to Narragansett Avenue and the famous Forty Steps, which have been rebuilt many times and are now inscribed with the names of financial contributors to their last reconstruction. Until you reach the Forty Steps, the only exit along this section is at Seaview Avenue.

Parking is available at Easton's Beach, where there is a swimming pavilion, a shop and restroom facilities. Alternative parking and restrooms can be found on Narragansett Avenue at the Forty Steps or on Webster Street.

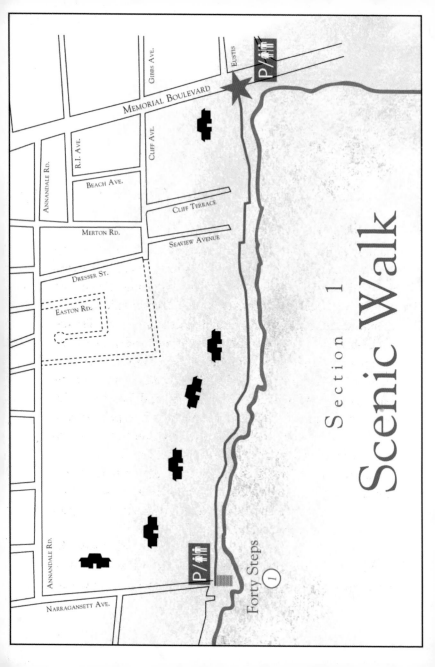

Section 1

Scenic Walk

MEMORIAL BOULEVARD

GIBBS AVE.

EUSTIS

P/🚻

ANNANDALE RD.

R.I. AVE.

BEACH AVE.

CLIFF AVE.

CLIFF TERRACE

MERTON RD.

SEAVIEW AVENUE

DRESSER ST.

EASTON RD.

ANNANDALE RD.

NARRAGANSETT AVE.

P/🚻

Forty Steps

①

Newport

A Mirror Reflecting the Gilded Age

Changes in the nature of technology over the last two centuries have created massive changes in the nature of wealth. Between the 1850s and World War I, the Industrial Revolution transformed the United States from a loosely knit agrarian economy into a powerful, dynamic one united by railroads, steel, coal, oil, electricity and, more recently, telephones and automobiles. The vast wealth and influence amassed by such men as Cornelius Vanderbilt, August Belmont, Andrew Carnegie, J.P. Morgan, P.A.B. Widener and Edward Julius Berwind was greater than that of much of Europe's nobility, many of whom flocked to marry their sons and daughters to those of these new kings of industry and finance.

The Industrial Revolution created a large addition to the upper-class elite, who lived fast-paced lives and escaped on long vacations to scenic summer resorts with plenty of sport and recreational opportunities.

The Gilded Age first arrived in Newport in 1847 with the advent of the Fall River Line steamships—luxury floating palaces propelled by paddle wheels—which gradually

displaced the smaller coastal ferry companies and provided daily service to and from New York until 1937.

Between 1880 and World War I, Newport had become the apex of summer resort architecture, social form and luxury. But in 1840, this area contained the farmlands and sheep pastures of a sleepy village of 8,334 inhabitants. It had largely failed to recover from the devastation of a three-year occupation by 6,000 British troops during the American Revolution, followed by further destruction in the War of 1812 and in the great storm of 1815.

Newport Origins

In 1639, a group of some thirty religious dissenters, banished from the Massachusetts Bay Colony, settled on this superb natural harbor and offered religious freedom to all. Newport grew over the next 137 years to be the fifth-ranking commercial seaport on the East Coast, trading in rice, flour, rum, candles, fine hand-crafted furniture, silver and more.

The first Newport Golden Age colony of wealthy merchants, craftsmen, gentlemen farmers, artists and intellectuals came to an abrupt end with the American Revolution, when Newport's population plummeted from eleven thousand to forty-five hundred. To keep warm, the British soldiers tore down some 400 vacant houses just to burn that lumber as firewood. Newport still has about 350 pre-Revolutionary houses today—maybe a third of all those surviving in the original thirteen states—and 10 buildings predating 1700.

Obscure Tailor Develops Resort

The largely unknown and unsung hero of Newport's Gilded Age was Alfred Smith, a successful but obscure tailor who returned in 1839 at the age of thirty to his native Newport with savings of $20,000. He had earned the fabulous sum of $6,000 a year custom making suits and coats for wealthy New York clients at the exclusive Wheeler and Co. tailors on Broadway.

Just four years before his return, Smith had already interested one of his wealthy and influential sartorial customers, William Beach Lawrence, in buying the sixty-acre Ochre Point Farm for $12,000 as a real estate investment. This farm included the strip of land along the shore that today is the site of five of Newport's grandest mansions. With a canny knack for real estate development, coupled with an interest in trees and landscaping, in 1845 Smith formed a syndicate with two others and bought three hundred acres south and east of the present site of the Viking Hotel on Touro Street, turning it into a grid of tree-lined lots.

The time was right—the great Greek Revival Atlantic House hotel on Touro Street had opened the previous year. The six-hundred-bed Ocean House farther down Touro (now Bellevue Avenue) opened in 1847. The Fall River Line steamships were just starting to run, and Newport received an avalanche of publicity in books and periodicals touting its scenic, climatic and recreational virtues, which later won it the title of the Queen of Resorts.

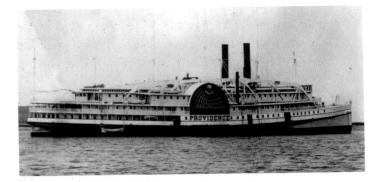

The SS *Providence*, which ferried passengers into Newport. *Courtesy of the Seamen's Church Institute, from the Wilfred E. Warren Collection.*

Luxury Floating Palaces Ran Overnight from New York City to Newport

In 1867, Jim Fisk purchased from a bankrupt firm the first three-deck steamers on Long Island and Rhode Island Sounds, the *Providence* and the *Bristol*, at one-quarter their cost. They were built in New York by William A. Webb, and each contained 240 staterooms to carry up to twelve hundred passengers and forty carloads of freight.

Fisk equipped his new ships like floating hotels, with plush velvet pile carpets, gilded chandeliers, gaslights, elegant salon and dining room furnishings and, for the inaugural run, two hundred canaries in golden cages hanging in the corridors and reception rooms. As a flamboyant former circus handler, Fisk certainly had a flair for the theatric.

He bought and converted the failed Pike Opera House for Broadway musicals, used the upper floors to house his railroad company headquarters and was known to stand at the top of the SS *Providence*'s gangway dressed in a full admiral's uniform, surveying his passengers before the ship departed from the New York pier. Fisk's Narragansett Steam Ship Co. twin liners were taken over by the Fall River Line after his death. The old *Providence* was scrapped in Boston in 1902, and the new *Providence*, commissioned in 1905, contained a whopping 346 staterooms, sleeping twelve hundred people and holding up to one hundred carloads of freight.

Both low and high society boarded steamships operating between New York City and Newport for ninety years until a strike in 1937 by the crew of *Providence* terminated this service. Records studied by the Newport Historical Society indicate that in the last sixty-three years of the steamships' runs, they transported more than eighteen million passengers—an average of eight hundred each night.

Smith Builds Bellevue Avenue

Smith did not rest on his laurels. In 1851, he formed a partnership with Joseph Bailey, who the previous year had inherited and otherwise acquired 140 acres in the area of Bailey's Beach, popular for saltwater bathing. The following year, through Smith's persuasion of the town council (and, later, thirty adjacent property owners), construction of the fifty-foot-wide Bellevue Avenue was begun. By the time

it was finished in 1853, Smith had planted hundreds of trees along it. (Presumably, the avenue was named after the Bellevue House hotel, which, strangely, was not located on Bellevue but on nearby Catherine Street.) In the winter of 1853–54, sixty new houses were built here, real estate values tripled and Alfred Smith was the seventh wealthiest man in Newport, according to the tax records.

No rest for Smith. In 1856, a public subscription was raised largely through Smith's efforts, and Bath Road, now called Memorial Boulevard, was rebuilt down to Easton's Farm and Beach. Smith was an astute real estate developer for selling the Bellevue Avenue lots and for including in the deed the right to use a swimming pavilion at Spouting Horn—now called Spouting Rock Beach Association or Bailey's Beach—which some, even today, claim to be the most exclusive beach club in the world.

Smith Builds Ocean Drive

Largely through Smith's efforts, Wellington and Harrison Avenues were built, followed by Ocean Drive, linking Harrison Avenue to Bellevue Avenue, in 1867. It provided a scenic horse-and-buggy ride all along the southern shore of the island, with views almost as spectacular as those along Cliff Walk—and you didn't have to get out of your carriage to see them.

During Smith's forty-one-year real estate career, he had aggregate sales of $21 million. In the summer of 1872 alone, he rented 106 furnished homes for $464,000, and in 1886, he

This is the house built by Alfred Smith, the "golden goose that laid gilded eggs," after returning to his native Newport with his $20,000 tailor's earnings and before he launched his fabulous Newport real estate career.

died, leaving an estate of just under $2 million. Not too bad for an obscure but successful tailor who returned to his native Newport to launch himself in a new real estate career.

People used to say that if Smith got you in his buggy, he wouldn't let you out until you bought some property. But they also said that he wouldn't sell a property unless the buyer had previously been approved by neighboring property owners. There aren't many sales agents today who make that sort of effort to create homogenous, exclusive neighborhoods. In fact, this tactic is called steering and is now an illegal real estate practice.

Newport High Society
The Names and Faces

Newport's summer colony of southern gentry, joined just before and after the Civil War by such artists and intellectuals as Edgar Allan Poe, William Wadsworth Longfellow, George Bancroft, Henry James, John LaFarge and Edith Wharton, had developed a quiet, gentle way of life. But it was soon to be overrun by a horde of new rich industrialists whose wives competed every bit as fiercely for social status as their husbands did for economic status. Their chief weapons were the things their wealth could buy.

Strenuous Business of Leisure

Society leaders competed by building larger and ever more authentic French-, Italian- and English-style manor houses, villas, palaces, gardens, stables and coaches. They staffed these mansions with trained footmen, coachmen, gardeners, butlers, valets, ladies' maids, housekeepers, chefs, governesses, tutors and chambermaids.

These mansions were stage settings for summer balls, banquets, galas, teas and receptions. All manner of employment agencies for staff, shops for exotic food, florists, tree nurseries, boatyards, carriage makers and harness

makers sprang up to meet the needs of the strenuous business of leisure.

A society lady had appropriate costumes, gowns and accessories for every occasion, available here during the summer season in those Bellevue Avenue branches of the most exclusive New York and Boston couture shops.

Staff Positions Competitive

The staff positions were competitive, with their own hierarchical pecking orders. While the butler or manager had a large command of the house, it was the lady of the house who was in charge and had to be a skilled "manager-hostess" to create a perfect evening for her guests.

The butler had overall responsibility for the first floor; the housekeeper, for abovestairs; the cook, for the basement kitchen; the assistant cook, for feeding the household staff; the laundress, for the family clothes; the laundress's assistant, for linens (staff laundry was sent out); the coachman, for the stables; and, of course, the head gardener, for the grounds.

A male cook might receive $95 a month; a French chef, up to $110; a butler, $65; and a housekeeper, $125—but a gardener or footman would earn $1 a day. According to a study by Rhode Island University professor Maury Klein made in conjunction with *Forbes* magazine, those dollars might be valued twenty-two to thirty-three times as much today. So today you might be able to hire a gardener for $33 a day if you threw in room and board, no income tax and probably some medical care.

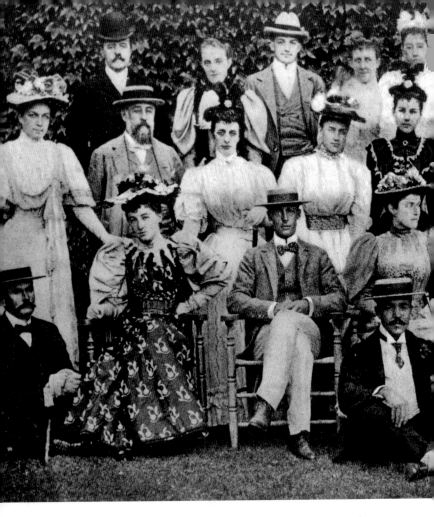

Thirty-one summer colonists, dressed in their latest Gilded Age society fashions, are shown here at the Newport Casino in 1892. *Seated in the second row*: Mrs. George Barclay (far left), the second Mrs. William K. Vanderbilt (third from right) and Mrs. John "Jacob" Astor 4th (second from right). *Courtesy of the International Tennis Hall of Fame.*

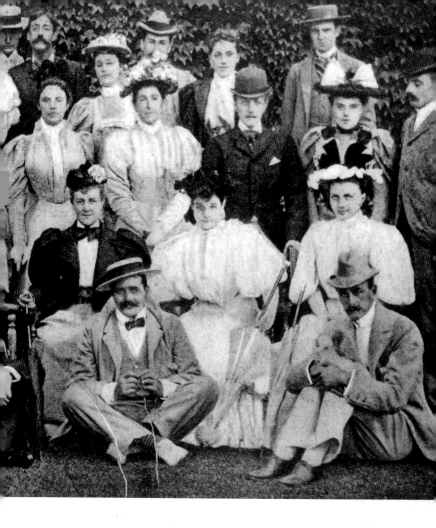

A Real Estate Bargain

Many of these mansions were cheaper to build in relation to today's dollars because of cheaper materials prices. Klein suggests a ratio of about fourteen times as many of our dollars to one of theirs for construction costs. The more exotic mansions around the turn of the century cost from $2 to $5 million, but Marble House—the most expensive at $11 million—could cost up to $154 million today.

But are we talking about the same materials and workmanship today? It's rather like comparing baskets of goods, only the goods in the baskets are different. At the turn of the century, according to Klein, a good cigar cost about $0.05; a pound of butter, $0.25; a case of French Bordeaux, under $8.00; a ton of heating coal, $4.00; an elegant men's beavertail coat, $14.00; men's leather shoes, $5.00; and the very best ladies' corset, just $0.62. And you could rent a little cottage on the sea for $750.00 for the summer and an elegant large house on Bellevue Avenue for ten summer weeks for between $2,000.00 and $5,000.00.

The Ladies Ruled and Manipulated

The new and fluid Gilded Age society developed new rules and rituals for gaining and maintaining social status, and the matrons who governed it worked relentlessly at their task. While the ladies ruled and manipulated the social calendar, the men, returning here on weekends, had their

own private clubs. The most prestigious were the Newport Reading Room, the Newport Golf Club, the Spouting Rock Beach Association at Bailey's Beach, the Clambake Club, the Newport Casino Club and the New York Yacht Club's Station Six (now the Mooring Restaurant), as well as fishing, rowing, polo, horseback-riding, coaching and gun clubs—each proud of its exclusive vetting procedures for membership.

Near the beginning of America's Industrial Revolution in 1855, New York City's population was only 675,000, but a stream of mainly foreign immigrants brought the population to 2 million in the 1880s. The Civil War also brought the city a flood of war profiteers and new-rich industrial barons. Many were poorly educated and uncouth, spitting tobacco and using a lot of four-letter words.

McAllister's "Respectable Poverty"

It was in 1872 that Ward McAllister of Savannah, Georgia, arrived in New York, fresh from studying British and European high society, with a plan to separate the wheat from the chaff in America's greatest city. "There are only 400 people in fashionable society," he told the *New York Tribune*. "Outside that number you strike people that are either not at ease in a ballroom, or that make other people not at ease there...a fortune of only $1 million." According to McAllister, a budding millionaire was still considered "respectable poverty."

Mrs. Harry Lehr said of McAllister:

> *No parish priest ever visited his flock with more loyal devotion to duty than did McAllister, making his rounds of the opera boxes…listening to plans for upcoming parties…offering his advice as to whom should be invited…discussing the wording of an invitation, while watching the neighboring boxes, whom they were talking to, who was taking up newcomers.*

Regarding newcomers to society, McAllister was always careful. "You had to see them at four or five of the best houses to make advances to them without the danger of making a mistake," he said.

Maud Howe Elliott, author of *This Was My Newport*, recalls McAllister's famous picnics:

> *When several coaches conveyed the guests to the sylvan spot…the band struck up a waltz…while McAllister iced the champagne. We sat at long tables and were served by the retainers of the different guests. Beauty was there to look upon, and wit to enliven the feast. The toasts given were brilliant; the cotillion, danced until sunset, was full of new figures and original favors.*

The "Mystic Rose"

McAllister teamed up with Mrs. William Backhouse Astor Jr. (whom he nicknamed "Mystic Rose") to lead New York society

A hand-colored photograph of a coaching picnic, 1894, at the annual meet of the New York Coaching Club, Newport, from the Souvenir Album of the Alan T. Schumacher Collection. *Courtesy of the Redwood Library and Athenaeum.*

and appoint some twenty-five so-called patriarchs from old New York families. Each was charged with carefully vetting and selecting four ladies and five gentlemen for invitations to Mrs. Astor's annual Patriarch's Ball. That invitation gave entry to balls given by other patriarchs—each invitee was observed for "worthiness" in the next round of invitations.

Commodore's Four-Letter Words

Mrs. Astor did not give out invitations to the four Vanderbilt brothers and their four sisters, possibly because their grandfather, Commodore Cornelius Vanderbilt, was one of those "new money" millionaires who spit a lot of tobacco and used a lot of four-letter words. The Vanderbilts were also still involved in "trade" (railroads), and Mrs. Astor believed that a man's family had to be out of trade for at least three generations "so the money would have a chance to cool off."

Commodore Vanderbilt's oldest grandson, Cornelius Vanderbilt II, built the Breakers. The commodore's second-oldest grandson was William K. Vanderbilt, and it was William K.'s wife, Alva Erskin Smith Vanderbilt, who forced Mrs. Astor to welcome the Vanderbilts into "the 400." Alva did it by persuading her husband to commission architect Richard Morris Hunt to build for them the greatest Second Empire–style French chateau that New Yorkers had ever seen at 660 Fifth Avenue in 1883. Then she sent out twelve hundred invitations to a costume ball. She did not send one to Mrs. Astor since Mrs. Astor had not recognized Alva.

But this was the year that Mrs. Astor's daughter, Carrie, was having her debut into society, and she had to have that invitation. To get it, Mrs. Astor had to send her footman with her calling card to Mrs. Vanderbilt's door—then the Vanderbilts were "in"!

A Ballroom for Twelve Hundred

When Mrs. Astor had Hunt build her new Fifth Avenue mansion in 1895, she had him design her new ballroom to hold twelve hundred guests—three times the size of her former Fifth Avenue and Bellevue Avenue mansion ballrooms. The room would not get much use, however—Mrs. Astor gave her last ball in 1905 and died in 1908. It was Alva Vanderbilt, Mrs. Herman Oelrichs (known as Tessie) and Mrs. Stuyvesant Fish (known as Mamie) who succeeded her as the new triumvirate of social queens. Together, these women ruled and set the standards more broadly for the ever-growing high society.

In 1890, McAllister, who had spent his life formulating rules of behavior for society, published his opus, *Society As I Found It*. Once these rules appeared in print, however, they appeared ridiculous. McAllister lost much of his flock, which left him for a new generation. He died in 1895, and Mrs. Astor took up with his replacement, Harry Lehr.

(1) Forty Steps on Cliff Walk

Continuing along Cliff Walk from Easton's Beach, you will reach Narragansett Avenue and the Forty Steps. The first of the famous Forty Steps were wooden and built during

the 1830s by David Priestly Hall so that his children could get down to the beach and Conrad's Cave just below. The steps, not always numbering forty, have been rebuilt many times—sometimes of stone, sometimes of iron—and most recently they have had the names of financial contributors inscribed on them. They are still frequented by lovers and tourists. During the Gilded Age, this was a favorite gathering place for maids when they had Thursday nights off. The maids would dance with their boyfriends—sometimes even youthful members of the Newport gentry—to popular tunes of the crippled accordion player, Dick Sullivan, an Irish slater who was injured after falling from a roof in 1920.

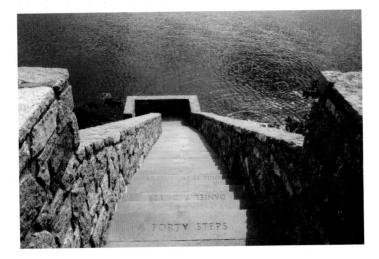

The Forty Steps.

MANSION WALK

This very walkable part of Cliff Walk runs about 0.9 miles from the Forty Steps to Marine Avenue. It offers great views of both the crashing waves below and the fabulous Gilded Age period mansions.

If you have come from the Common Beach, continue south past the Forty Steps to Webster Street, where parking is also usually available.

This section of the tour starts one block west on Webster Street at the corner of Ochre Point Avenue and inside the gates of Ochre Court Mansion, now used by Salve Regina University as its administration building.

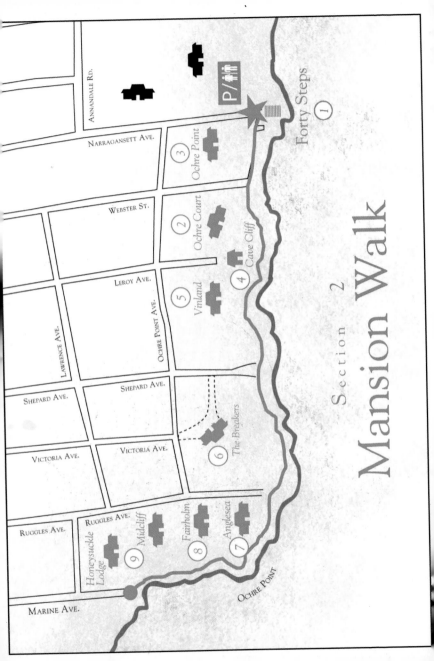

Ochre Court

This French Gothic–style chateau with its free adaptation of sixteenth-century Renaissance elements was built of Indiana limestone between 1888 and 1891 at a cost of $4.5 million. Ochre Court has the distinction of being one of the first grand Beaux Arts–style palaces completed by Richard Morris Hunt in Newport.

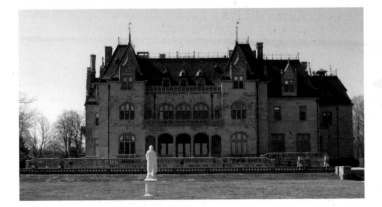

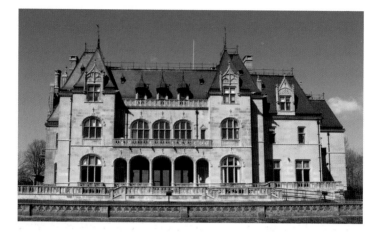

A view of Ochre Court from the east.

Thrifty French Huguenots

Ochre Court was built for Ogden Goelet, who shared with his son Robert large blocks of New York real estate lying between Union Square at Fourteenth Street and Forty-seventh Street to the north, with an estimated book value of approximately $100 million. The Goelets were descendants of thrifty French Huguenots who liked to sew their own clothes, use the back of envelopes as stationery and even still milked their own cow. However, the members of this generation had become much more liberal with their finances.

The Marrying Wilsons

Ogden Goelet was married to May Wilson, daughter of Mr. and Mrs. Richard Thornton Wilson (reported to have lived at Bienvienue on Narragansett Avenue), whose three daughters and one son married so well that they were known as "the marrying Wilsons." Their son, Orem, married Caroline, daughter of Mrs. William Backhouse Astor Jr., while their daughter Belle Wilson married the British ambassador to the United States, Michael Henry Herbert, an heir to the Earls of Pembroke. Their second daughter, Grace, married Cornelius Vanderbilt III, the oldest surviving son of Cornelius Vanderbilt II. Unfortunately, Grace's husband received only a $1.5 million inheritance from his father, who allegedly considered his daughter-in-law's father to be a Civil War profiteer and highly disapproved of the marriage. (Mr. Wilson had made a fortune restoring southern railroads after the Civil War, as well as in banking later on in New York.) The $37.5 million share previously earmarked for Cornelius was allotted to his next oldest brother, Alfred.

Three-Story-High Great Hall

The great hall inside Ochre Court is three stories high. The ceiling painting portrays the gods of Olympus holding a banquet and is supported by twelve Mannerist-style caryatid figures. There is also a drawing room in Louis XIV style overlooking the ocean, a Rococo ballroom and library, a

Ochre Court.

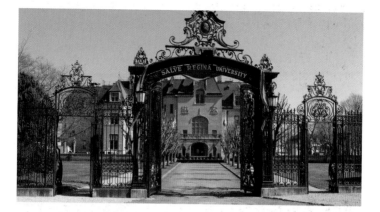

University gate, Salve Regina.

Tudor-style study, a state dining room and a Louis XV–style family dining room.

Salve Regina now uses Ochre Court as its main administration building. The university was founded as a women's college by the Sisters of Mercy in 1934 and was given this Newport estate in 1947. Today, it owns nearly a dozen estates here and has an enrollment of twenty-two hundred men and women. During class days, the university welcomes visitors to this building.

True Lies *Movie Set*

Any Arnold Schwarzenegger fan will appreciate a visit to Ochre Court, as many of the outdoor scenes in the film *True Lies* were filmed here, while some of the inside scenes—

including a tango sequence—were shot in Rosecliff Mansion, located farther down Bellevue Avenue.

During the period in which Richard Hunt was building Ochre Court, he had three other mansions under construction here: Marble House for William K. Vanderbilt; Belcourt for Oliver Hazard Perry Belmont; and Wrentham House for J.R. Busk on Ocean Drive.

These were hardly finished when Hunt began work on four other major building designs: the Breakers, just down the street, for William K. Vanderbilt's older brother, Cornelius II; the Biltmore, in Asheville, North Carolina, for William K.'s youngest brother; Mrs. Caroline Astor's Fifth Avenue mansion

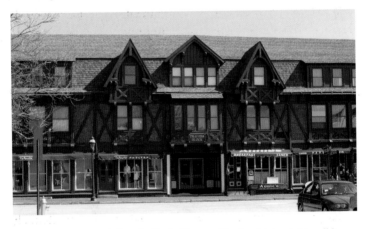

In 1870–71, Richard Hunt built the Travers Block, which might well be called Newport's first shopping mall. Located at the corner of Bellevue Avenue and Memorial Boulevard, the Travers Block pioneered an upscale shopping area for Newport's soon-to-come wealthy summer colonists.

in New York City; and the Fifth Avenue front entrance wing of the New York City Metropolitan Museum of Art.

Of course, his most widely known work is the base and pedestal of Bartholdi's Statue of Liberty at the New York Harbor entrance, but many critics say that his greatest work was the administration building of the 1893 Columbia Exposition in Chicago—tragically destroyed by a fire the following year.

First American Architect

In 1852, Hunt completed his sixth year of study at the prestigious École des Beaux Arts in Paris and was the first American architect to have studied there. Before returning in 1855 at the age of twenty-seven to open offices in New York, Hunt served as second in command under Hector Lefuel in the design of a new wing to the Louvre Palace, the Pavilion de la Bibliothèque.

Hunt was known in his day as the dean of American architects. He was a founder and served as secretary, and later president, of the American Institute of Architects. He established his own atelier for teaching apprentice architects in New York City in 1857 and introduced the Beaux Arts style to American building design—much to the disgust of the followers of Frank Lloyd Wright.

Richard was the fourth of five children of a moderately wealthy Vermont congressman who died when Richard was four. He was fourteen when, because of his older brother William's poor health, his mother decided to take the whole

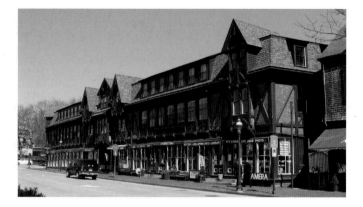

Another view of the Travers Block shopping plaza.

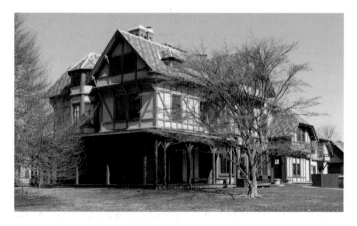

The J.N.A. Griswold House, opposite Touro Park on Bellevue Avenue, was the earliest major work (1861–63) by Richard Morris Hunt in Newport after he joined his brother William as a summer resident. Their house and studio, Hill Top, once stood where the Viking Hotel now stands. Notice the half timbering and post-and-beam construction with deeply recessed porches, reminiscent of the European style.

family to France for their education. William Morris Hunt came under the influence of such French artists as Couture and Millet and later became well known in America for working in French styles.

Next, go down Webster Street to the right to see a mansion in a very different style, built for Ogden Goelet's son Robert some nine years earlier. It is visible through the wooden fence on Webster Street and again after turning north on Cliff Walk.

③

Ochre Point

Robert Goelet's Shingle-style mansion, variously called Ochre Point or (erroneously) Southside, was built between 1882 and 1883 by the New York firm of McKim, Mead and White. This firm pioneered the use of the Shingle style in Newport with the construction of the Newport Casino between 1879 and 1881.

Near the middle of the nineteenth century, the severe symmetry of classical design began giving way to the asymmetrical and picturesque late nineteenth-century Victorian styles: the Stick, the Queen Anne, the Shingle and the Richardsonian Romanesque.

The Shingle style takes the irregular shapes, gables, cross gables, gabled dormers, multipaned windows, second-floor

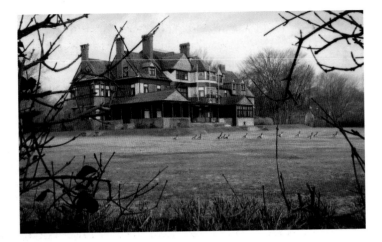

Ochre Point Mansion.

loggias and wide porches or piazzas of the Queen Anne style but adds a variety of shingle patterns to further break up the irregular treatment of wall surfaces on different levels of the building. It incorporates brick on the first level and stucco panels on upper levels.

The Shingle style also takes from the Queen Anne style the use of interior space: a great hall featuring an enormous colonial-looking inglenook fireplace; a dramatic multilanding stairway; and, radiating from the central hall like spokes of a wheel, the drawing room, dining room, library and vestibule.

Robert's son, Robert Jr., married Elsie Whelen, who was gorgeous but poor. Elsie soon divorced him and married Henry Clews, who owned another estate called the Rocks.

Descendants of the Goelet family still own Ochre Point and sometimes vacation here. The high fences and shrubbery surrounding Ochre Point make it difficult to view, but it is visible from Cliff Walk.

Other Shingle-Style Homes

Other Shingle-style homes under construction by McKim, Mead and White included the Isaac Bell Jr. house on Bellevue Avenue (now under reconstruction by the Preservation Society); the Samuel Coleman house on Red Cross Avenue; the Samuel Tilton house on Sunnyside Place; and the dining room addition to Kingscote, also on Bellevue. All of these are spinoffs of the James Gordon Bennett Jr. commission to build the Newport Casino Club across the street from the site of Bennett's mansion, Stone Villa. The villa had been built in 1853 for the Charleston, South Carolina plantation owner Henry Middleton by Alexander McGregor, who was also the stonemason for Fort Adams and St. Mary's Roman Catholic Church, among others.

Bennett, a great and colorful sportsman and commodore of the New York Yacht Club, inherited $7 million and took over as owner and publisher of the *New York Herald* (later the *New York Herald Tribune*) on his father's death in 1872.

Bennett in Rascally Mood

Often in a rascally mood, it was Bennett who, in 1869, sent his news reporter Stanley on a three-year hunt in darkest

Africa to search for the noted scientist Dr. Livingston. The stunt greatly boosted the *Herald*'s circulation, even though Livingston claimed that he had never been lost at all.

One day in the summer of 1879, Bennett challenged his visiting British friend and fellow polo player Captain Henry Augustus "Sugar" Candy, a retired officer of the Ninth Queen's Royal Lancers, to ride his horse in the front door of the exclusive Newport Reading Room. When the club members not only censured Bennett but also stripped Candy of his temporary membership in the club, Bennett announced that he would avenge their actions by building his own club— the Newport Casino.

White's Apprenticeship

It was in September 1879 that twenty-five-year-old Stanford White joined the firm of McKim and Mead, after an eight-year apprenticeship under Henry Hobson Richardson followed by a fourteen-month study tour of Europe, where especially the Italian-Renaissance style of architecture seemed to have stolen his heart. White had been merely sixteen when he began his apprenticeship with Richardson in 1870, having only a flair for drawing and painting as background. Richardson had returned to New York in 1865 as the second American to have studied at the École des Beaux Arts in Paris, and his chief draftsman, Charles McKim, was the third American to have studied architecture there.

White's progress was so rapid that he replaced McKim as director of the plans for Boston's Trinity Church in 1872,

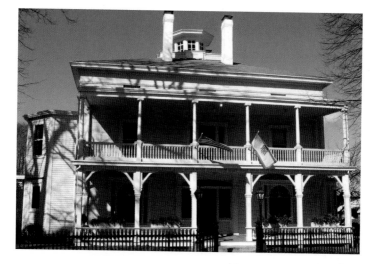

The Newport Reading Room, originally built as a hotel in 1835, was converted into the most private men's club in Newport by local architect George Champlin Mason in 1853.

when McKim resigned to set up his own architectural firm. Before leaving Richardson, White had played a major role in designing the marble senate chamber of the New York State Capitol Building in Albany.

William Rutherford Mead, affectionately called "Dummy," was a silent partner with McKim, Mead and White. He ran the payroll, hired and fired and supervised the financial arrangements, as well as planned construction engineering, heating and plumbing and kept the architectural projects moving. A graduate of Amherst College and a student of the Accademia di Belle Arti, in Florence, Italy, this native

of Brattleboro, Vermont, was soft-spoken, handsome and smoked cigars constantly.

McKim, Mead and White came to be known as the most successful architectural firm in the country. By 1910, the partners had a staff of ninety-two and had handled more than seven hundred commissions with a total construction cost in excess of $36 million.

Newport Casino

For his first major project in 1879, White assisted McKim and Mead in designing the decorative detail of the Newport Casino. The Casino's horse and flower shows, horseshoe piazza for viewing, tennis and court tennis tournaments, ballrooms and theatre, reading and dining rooms, card and billiard rooms and clubrooms and bachelors' quarters would come to serve as a pattern for similar clubs across the country.

Designed in the Shingle style and inspired by New England colonial buildings, the Casino also cemented an important business relationship with Bennett and opened the door to White's firm for a long series of commissions for mansions, public buildings and (especially for White) clubhouses.

The Newport Casino's north wall, with its Loire Valley–inspired clock tower, was completed in 1881 by New York architects McKim, Mead and White. This work inspired the construction of many Shingle-style homes in Newport. With its international tennis matches, concerts, balls and

The Newport Casino. *Courtesy of the International Tennis Hall of Fame.*

theatre, the Casino truly became the center of Newport social life. In her autobiographical book, *King Lehr and the Gilded Age*, Elizabeth Drexel Lehr describes the typical Casino scene:

> *Mornings* [were] *spent on Bailey's Beach, or on the Horse Shoe Piazza at the Casino, where women who prided themselves on their ultra-feminine poise and despised the sports girl whose era was fast dawning, sat arrayed like Solomon in all his glory, listening to the strains of*

Mullalay's orchestra. Such clothes! How they swished and rustled! Petticoats of satin, of lace, of taffeta; petticoats embellished with elaborate designs of plump cupids playing gilded lyres, true love knots interspersed with doves embroidered in seed pearls; parasols to match every dress, enormous flopping feather hats assorted to every costume. White gloves to the elbow, three or four new pairs every day, priceless lace ruffles at the throat and wrists, yards of lace flouncing on underskirts, thousands of dollars worth dragged over the Casino terrace. Different dresses for every occasion, eighty or ninety in a season, worn once or twice and put aside. On the Casino courts, the…sports costumes [were] *considered the last word in daring— white tennis shoes and black stockings, white silk blouses, pleated skirts which, fluttering in the breeze, exposed… oh horror, bloomers! Sailor hats to which were attached double veils protecting their faces from the outrages of the sun. Down on the beach, the bathers disported themselves in the propriety of full-skirted costumes and long black stockings.*

Among the best known of White's designs are the Madison Square Garden, the Metropolitan Club, the Century Association Club, the Colony Club and the Players Club—all in New York, and all but the first still standing today. Best-known works for McKim were the Boston Public Library and the now leveled New York Pennsylvania Railway Station, as well as the Low Library and other buildings at Columbia University.

History of Cliff Walk

The first written mention of Cliff Walk is in an 1852 travel book by George W. Curtis called *Lotus Eating: A Summer Book*. It describes leaving the horses behind and following a path along the cliffs and over stone walls, extending only from what is now Narragansett Avenue at Forty Steps northward to Easton's Beach, which you can see in the distance.

This book also sets out the first written claim that Cliff Walk has always been a public right of way: "When the colonists took the land from the Indians in 1639, a right of way along the sea was secured to them forever for fishing and for the gathering of seaweed." It goes on to state that this right seemed to be reaffirmed by the 1663 Rhode Island charter from Charles II, which was in part incorporated in the Rhode Island state constitution of 1843: "The people shall continue to enjoy and freely exercise all rights of fishery, and privileges of the shore, to which they have hithertofore been entitled under the charter."

The year 1852 is not only the year in which the first mention of Cliff Walk is to be found, but it was also the year after Alfred Smith formed his partnership with Joseph Bailey, and it was the year that Richard Morris Hunt completed his studies at the École des Beaux Arts in Paris.

A year later, in 1853, Bellevue Avenue was completed, the New York City Council approved the creation of Central Park and the Crystal Palace Exposition opened in New York's Bryant Park behind what is now the New York Public

Library at Forty-second Street and Fifth Avenue. Stanford White was born that year on East Tenth Street near St. Mark's Church on Broadway (where there were fifty-two taverns and twenty-seven oyster houses, perhaps explaining why Stanford White's favorite expression was "Holy Moses, gin and seltzer"). Also that year, the New York Central Railroad was established from a union of twelve small lines.

Origin of Cliff Walk

The first reference of Cliff Walk running its present length from Easton's Beach southward four miles to the end of Bellevue Avenue at Bailey's Beach occurred in 1875. The same year we find the first mention of a property owner attempting to block the walk as a public right of way by building four houses directly in the pathway. Public opposition was so strong, however, that the owner was forced to construct a path between the houses.

We do have a map of Newport, drawn in 1780, that shows at that time only twenty dwellings south of Newport Harbor—six of them along Coggeschall Avenue on the far side of Bellevue—and none in the area to the east of the harbor. The deeds for the construction of Narragansett Avenue are dated 1840.

"Hogs' Hole"

The first written reference we have to this spot, located adjacent to the Forty Steps, is in a travel account by a Dr. Alexander

Hamilton in 1744, when it was known as "Hogs' Hole." He claimed that there was a natural spring here and cool shade and that the ladies used to come here to make tea. Afterward, he mentioned an "abundance of gallantry and romping" in the shade of the trees. Exactly what he meant by these terms, I will leave to your imagination. Perhaps it was just a game of tag.

Today, there are fifty-seven lots crossed by the walk, and nineteen of the property deeds refer to a possible public right of way in the event of a liability case. Until such a case materializes, however, the owners will deny that such a clause exists.

Public Spying on Mansion Properties

As early as 1857, owners began spending thousands of dollars to upgrade and beautify the walk, so that by 1897, an ordinance was passed to ban the use of bicycles. In the 1890s, public spying and trespassing on the mansion properties of the rich became so prevalent that the Goelets, Astors and Vanderbilts began sinking the walk below eye level of their properties and building wall screens for privacy.

For generations, Cliff Walk has been a favorite place for strolling and meeting, and many Newport marriages are said to have fermented in this place of spectacular views from the cliffs that drop down to the sea.

On stormy days, the waves beat relentlessly against the rocks. The cliffs have been subjected to continuous erosion by great storms, especially in 1912, 1938, 1945 and 1954, when large sections fell into the sea. Property owners were

left to repair the damage on their own until 1945, when some municipal funds were first provided. A city mayor's application for federal funds failed that year, and in 1959 an application to make Cliff Walk a part of the National Park System was also rejected.

Then, in 1971, the Army Corps of Engineers approved a beach erosion project along the cliffs. In 1975, Cliff Walk was designated a National Recreation Trail. In 1980, Senator Claiborne Pell of Rhode Island fell while jogging on Cliff Walk, and in 1987 the senator introduced legislation to make it part of the National Park System (which unfortunately did not pass).

Von Bulow Gets Funds

In 1975 and '76, a committee headed by Claus von Bulow and Mayor Donnelly obtained federal, state and municipal funds for partial restoration of the walk, as did another committee in 1984–85.

Following the 1938 hurricane, Mrs. John Russell Pope, of the Waves mansion at the end of Ledge Road, attempted to build a wall to close off the walk. The state attorney general intervened, and Mrs. Pope later said, in the face of a storm of protests, that her effort was an "innocent mistake." Indeed, the public right of way along the walk seems never to have been truly tested in court but is maintained by the public will.

As you continue south along Cliff Walk, take care not to touch any bright green plants—poison ivy is common in the area.

Also remember to watch out for bees—if you shoo them away they might try to sting you.

Cave Cliff

Continuing along Cliff Walk, you will encounter a modest white house called Cave Cliff, built with a mansard roof in 1877 for Ohio senator George Hunt Pendelton (whose legislation created the first Civil Service Commission). The architect Detlef Lienau, who built Anglesea, is credited with popularizing this French-style roof in America, though he did not actually build Cave Cliff. The house was built by local architect James Fladder and is still privately owned.

Bennett Becomes a "Pariah"

It was on New Year's Day a year earlier (1876) when *New York Herald* owner James Gordon Bennett became a pariah to New York society. He was celebrating the announcement of his engagement to Caroline May at her family home, when, feeling the call to nature, he relieved himself then and there in the fireplace, claiming that there was not a bathroom within half a block.

Cave Cliff.

Caroline's brother, Fred, horsewhipped Bennett and forced him into a duel, in which both men fired into the air. Though no one was hurt, Bennett was socially ostracized and afterward lived mostly in Paris, where he published the Paris edition of the *Herald Tribune*.

Boss Tweed "Exposed"

In the year following the construction of Cave Cliff (1878), New York's Tammany Hall Boss William Tweed was exposed by the *New York Times* for graft estimated at between $75 and $200 million. Tweed died in a New York prison that same year.

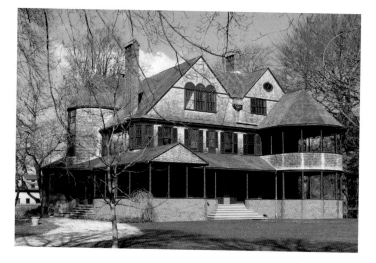

After completing Bennett's Newport Casino, the architectural partners McKim, Mead and White built this whimsical blend of asymmetrical revival architectural styles, the Isaac Bell House. Bennett's sister Janet had just married Bell, a retired, wealthy cotton merchant. Famous for his sense of humor, Stanford White instructed his mason to add one more tile to the fireplace tiles depicting rural peasant scenes that showed Bennett relieving himself in a fireplace.

The year 1878 was also when New York's Museum of Natural History was built, and in the following year (1879), architect James Renwick's St. Patrick's Cathedral on Fifth Avenue was dedicated. Daniel Drew, who along with James Fisk and Jay Gould wrested control of the Erie Railroad from Commodore Vanderbilt by printing new shares of stock faster than the commodore could buy them up, died bankrupt in

the same year. In 1879, the first arc lights lit up the faces of New Yorkers, the city telephone directory listed 250 phone numbers and Stanford White joined the architectural firm of McKim and Mead.

Gold Flatware and Orchids

In the 1880s, as the great new mansions of the Vanderbilts went up along Fifth Avenue (six of them between Fifty-first and Fifty-ninth Streets), gold flatware at the banquet tables began to replace silver flatware, and the hothouse orchid began to replace the American Beauty rose as the preferred table decoration.

(5)

Vinland

The next mansion we'll see is Vinland, the brownstone, Queen Anne–style house built by Boston architects Robert S. Peabody and Alan Stearns between 1883 and '84 for Catherine Lorillard Wolfe, a very wealthy maiden lady who provided funds to build Grace Church in New York City. Though she remained a maid, Catherine received so many marriage proposals that she had her calling cards printed with her name and, beneath it, the inscription: "Not Interested in Matrimony."

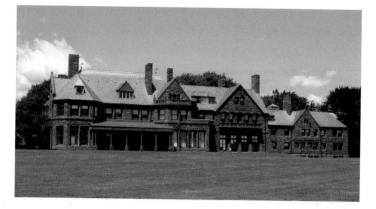

Vinland.

Her father's house was located on Newport's Touro Park in plain sight of the "Viking Mill," which most historians say was built about 1658 by Rhode Island's early governor Benedict Arnold (great-great-grandfather of General Benedict Arnold, the infamous Revolutionary War traitor).

Vikings' "New World"

Catherine Wolfe's faith that the twelfth-century Viking explorers built the mill was so great that she named this mansion Vinland, which in the Norse language means "New World." The interior decorations and stained glass were loaded with Viking symbols, and a mural in the dining hall illustrated a William Wadsworth Longfellow poem about a Viking knight-in-armor—reportedly found in a grave in nearby Fall River, Massachusetts.

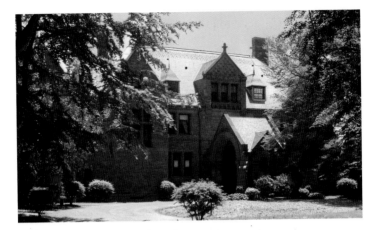

Entrance to Vinland.

The new Breakers mansion next door was completed for Cornelius Vanderbilt II by Hunt in 1895, and the following year Hamilton McKay Twombley—married to Vanderbilt's sister Florence—bought Vinland. But Florence Vanderbilt didn't care much for Viking symbols. She commissioned Peabody and Stearns to come back and remove them and enlarge the house. However, she kept the name Vinland.

Florence, along with her three sisters and four brothers, was a child of William Henry Vanderbilt. William Henry was one of three sons, but he also had nine sisters—all the children of Commodore Cornelius Vanderbilt and his first wife, Sophia Johnson.

Commodore Elopes with Thirty-One-Year-Old

Sophia died in 1868 after fifty-five years of marriage. The commodore, who was seventy-five and had made a vast fortune in steamships and railroads, eloped to Canada the following year with a thirty-one-year-old woman named Frank Crawford. He feared that his twelve children would object, which they did to no avail.

Florence and her husband, Hamilton, also had a one-hundred-room mansion built by McKim, Mead and White in Madison, New Jersey, which they called Florham, short for their first names. Vinland was later acquired by Salve Regina and for years was used to house the university's library. Florham was later acquired by Fairleigh Dickinson University and was used as the administration building.

Dowager Fears Kidnappers

Florence was the last surviving grandchild of the commodore before her death at the age of ninety-eight in 1952. The year before her death, one of her grandchildren was getting married in California. Though she feared kidnappers, Florence was determined to have her chauffeur drive her to the wedding in one of her Rolls-Royces. To protect herself, she dressed as her maid and sat next to the driver. Her maid had to dress up as the old dowager and sit in the backseat. All three made the trip to California and back again safely, but Florence died soon after their return.

While Peabody and Stearns were beginning work on Vinland in 1883, Stanford White was completing construction of the brownstone Villard Cottages on Madison Avenue for Northern Pacific Railroad magnate Henry Villard. Years later, the building was used as headquarters for Random House Publishing, and more recently it was made into the Helmsley Palace, ruled by Leona Helmsley until her conviction for tax evasion.

The year 1883 was also when the Brooklyn Bridge, a 5,989-foot span over the East River, was dedicated after thirteen

Side view of Vinland.

years of construction supervised by Washington Roebling, son of the bridge's deceased designer, John Roebling. The day following the dedication, 150,000 people crossed that bridge, which is suspended some 1,600 feet above the water.

6
The Breakers

Next along Cliff Walk is the Breakers, Newport's grandest mansion, modeled after Renaissance palaces in Turin and Genoa, with seventy rooms on five levels. The first floor covers some twenty-four thousand square feet, or slightly more than half an acre of this thirteen-acre estate. This mansion is built of Indiana limestone, and though modeled after Italian palaces, it is loaded with Beaux Arts–style sculptural detail. Though it is not usually considered the most successful Newport design, what it may lack in style it certainly makes up for in detail and size. Its dining room and great hall dimensions would each accommodate an average-sized house.

Newport's Grandest

The Breakers was built in two and a quarter years by Richard Morris Hunt for Cornelius Vanderbilt II, who inherited $67 million on the death of his father, William Henry Vanderbilt,

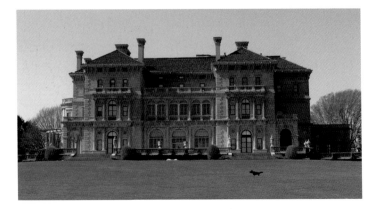

The Breakers.

in 1885. His next oldest brother, William K. Vanderbilt (married to Alva Smith), inherited $65 million (and had Hunt build the $11 million Marble House on Bellevue Avenue, as well as his Fifth Avenue mansion in New York and another on Long Island). Cornelius II's two youngest brothers, Frederick William and George Washington Vanderbilt, like his four sisters, inherited only $10 million each—their father's will was designed to keep control of the railroad stock in the hands of the two older sons.

He Dies Before Party

When he began work on the Breakers, Hunt was at the height of his career. He had major buildings underway in five cities, including the 255-room, French Gothic–style Biltmore

Mansion for George Washington Vanderbilt in Asheville, North Carolina, and the year before he had completed the great main administration building at the Columbia Exposition in Chicago. His many projects and ill health probably shortened his life. He died on July 31, 1895, at age sixty-seven—just three weeks before the first party at the Breakers.

The First Breakers

Located on a point of land where rocks and ocean rollers meet on stormy days, the sound of breaking waves gave this mansion its name. But it is really the second mansion on this site to receive this name. The original wood-frame, Shingle-style mansion was completed in 1878 by Peabody and Stearns of Boston for tobacco magnate Pierre Lorillard. It was sold to

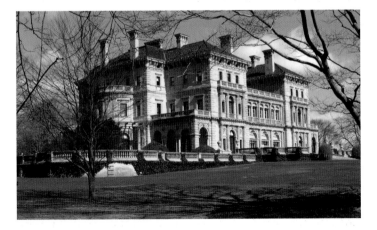

Terrace view of the Breakers.

Cornelius Vanderbilt II in 1885, the same year he inherited his fortune and was named chairman of the New York Central and several other railroads.

In 1892, the original Breakers burned to the ground because of a faulty furnace. To prevent a recurrence in the new Breakers, the heating plant was installed in the basement of the gatekeeper's cottage at the main gate and connected to the mansion by a tunnel big enough to drive a team of horses through. In the winter, the enormous hot water pipes running through the tunnel provide heat for preserving the mansion's art collection. These summer cottages in Newport were generally only used from July through September.

Cost of the Breakers?

Vanderbilt heirs claim that the construction cost of the Breakers is unknown. However, Cornelius III, who was disinherited by his father (except for $1.5 million) for marrying Grace Wilson, told his son Cornelius IV that the Breakers cost about $5 million—in line with the price of Ochre Court.

The $11 million Marble House is reported to contain $7 million worth of rare marble. Replace that marble with limestone and you might again be looking at a $5 million house. And the Elms Mansion, about half the size of the Breakers, was built for $1.4 million—but there, Mr. Berwind's coal might have been bartered for limestone and marble, reducing the cost figure.

Death and the Vanderbilt Inheritance

Cornelius II lived to enjoy only four summers at the Breakers. In 1896, just a year after moving in, a stroke confined him to a wheelchair, and in 1899 a second stroke caused his death at the age of fifty-six. He was a pillar of the Episcopal Church, served on several vestries and committees for various charities and, with his brothers, founded the Vanderbilt Clinic at Columbia University in New York.

Cornelius II's oldest son, William Henry II, died of typhoid fever at Yale University in 1892. His second-oldest son, Cornelius III, had his expected $37 million inheritance reduced to $1.5 million when he married Grace Wilson. His third-oldest, Alfred Gwenn, inherited his brother's $37 million share and married Elsie French in 1901.

Adultery: Cost $10 Million

In 1908, however, Elsie sued Alfred for divorce on grounds of adultery with the wife of a Cuban diplomat on Alfred's private railway car, the Wayfarer. For Elsie, the testimony of Alfred's valet was the key to a $10 million divorce settlement and custody of their son.

In 1911, Alfred married Bromo Seltzer heiress Margaret Emerson McKim (unrelated to the architect), and in 1912 he bought a ticket to sail on the maiden voyage of the *Titanic*. Then, at the last minute, he decided not to board.

Luck Didn't Hold

But Alfred's luck didn't hold. In 1915, he was onboard the British liner *Lusitania* when two German U-boat torpedoes struck the side of the ship, and he drowned with some twelve hundred other passengers, having given up his life jacket to save another. Alfred left an estate of $26 million—$5 million of it to his son, William Henry III, who later became governor of Rhode Island.

Great Horse Breeders

Reggie Vanderbilt was the youngest of Cornelius II's four sons, and like Alfred he was a great horse breeder. On his twenty-first birthday in 1902, Reggie inherited an initial $5 million, walked into Richard Canfield's New York Casino at 5 East Forty-fourth Street and dropped $70,000 in one night.

In 1903, Reggie married Cathleen Neilson, but in 1912 he deserted her and her daughter in Paris without money or explanation, prompting her to divorce him. Later, during a police raid of Canfield's New York Casino, they found $300,000 worth of IOUs from Reginald Vanderbilt.

All Vanderbilt Women Have Pearls

In 1923, forty-three-year-old Reggie married seventeen-year-old Gloria Morgan, daughter of a middle-class diplomat. You may have seen the Bette Davis movie in which, as Mrs.

Vanderbilt, Davis asks the butler to bring scissors to the banquet table and cuts off a third of her $200,000 pearl necklace. Handing it to Gloria, she tells her, "All Vanderbilt women have pearls."

Reggie Takes a Cure

For the next two years, Reggie and Gloria celebrated the Roaring Twenties in speakeasies, at horse shows and on European trips. Daughter "Little Gloria" was born. Then Reggie suffered a series of physical breakdowns.

The doctor ordered Reggie to spend some time in Vichy, France, for the sake of his health. But on returning home to Sandy Point Farm, just outside Newport, he went down to the Newport Reading Room and drank cocktails with friends. Two weeks later, he suffered internal hemorrhaging and died at the age of forty-five. Nothing was left but his original $5 million trust fund. Then followed the custody suit for Little Gloria by Reggie's sister Gertrude, who had married the very wealthy Harry Payne Whitney.

After her marriage, which took place in the very ornate music room of the Breakers, Gertrude became interested in sculpture, and on first seeing her work, architect Stanford White was so impressed that he arranged for her to take lessons in New York and Paris. One of her better-known works is a statue of Bill Cody on his horse, in Cody, Wyoming. And later, in 1930, Gertrude founded the Whitney Museum of American Art in New York City.

Heirs Sell Breakers

It was Gertrude's younger sister Gladys who, in 1908 at the age of twenty-one, married Count Laszlo Szechenyi, later the royal Hungarian minister to the United States, and leased the Breakers to the Preservation Society of Newport County for one dollar a year. That arrangement lasted for twenty-four years, until, in 1972, her daughters sold the mansion to the society for a nominal amount. The countess's, and later her daughters', support greatly aided the society to acquire nine other Newport mansions and open them to the public.

But it was Cornelius Vanderbilt, universally known as the commodore, who founded his family's fortune at the age of sixteen with a $100 ferryboat on Staten Island. He got that money from his mother after promising to clear a five-acre field on their farm for planting. Like Tom Sawyer, he promised his friends rides on the boat if they helped him clear the field.

The commodore ferried produce to New York markets and, over the course of sixty years, created a huge steamship fleet operating on both coasts and to La Havre, France. Then he sold it and in 1862 bought the Harlem River Railroad; two years later, he acquired the Hudson River Line; and finally, in 1875, he established the first through train to Chicago, the White Mail Train. It made the trip in only thirty-six hours—think how long that would have taken by stagecoach!

Commodore Sailed Own Ships

The commodore was known to sail his own ships, he could curse better than any barge captain on the East Coast and he fought like many other entrepreneurs of his day, manipulating stock, buying judges and legislators and generally besting his financial opponents (with the exception of his defeat by Jim Fisk, Jay Gould and Daniel Drew. The three won control of the Erie Railroad by printing new shares of Erie stock certificates faster than the commodore could buy them up. Drew, however, ended up bankrupt after switching sides in the dispute three times!).

They say that the commodore hated paperwork—that the only things in his office desk in Grand Central Station were a checkbook and a box of cigars. His usual morning routine, after lamb chops, egg yolks and black coffee for breakfast, included spending a few hours at the office, driving his horse and buggy in the afternoon (during which time he was known to drink an unusual mixture of gin and sugar) and playing high-stakes whist at the Manhattan or Union Club in the evening.

Thrifty Commodore's Gift

A gentleman once asked the commodore why he kept his cigars in his coat pocket instead of getting a cigar case. He said, "If I keep them in my coat pocket and take one out, nobody knows how many are in there. But if I get a cigar case and take one out, everybody knows, and I've gotta pass 'em around!"

It is said to be the generous influence of his young second wife, Frank Crawford (his first cousin twice removed), who prompted the commodore in 1873 to give $500,000 to Methodist Central University in Nashville, Tennessee, at a time when such gifts were rare. The university officials were so pleased that they changed the institution's name to Vanderbilt University. This, in turn, so pleased the commodore that he gave them another $500,000.

Not a Churchman?

Though not known to have attended church (unless you count a séance in which he tried to conjure up the ghost of Jim Fisk to ask him for advice on the current market in railroad stocks), the commodore did fund $50,000 for the Mercer Street Congregational Church around the corner from his home at 10 Washington Place in New York. He gave that church to his new wife's clergyman friend Dr. Charles Deems, who renamed it Church of the Strangers. Sometime friend Daniel Drew was numbered among its congregants, but the commodore is never known to have entered it.

Commodore's Farewell

In May 1876, the commodore was stricken with cancer. News reporters rented a room across from the commodore's townhouse to keep check on his condition. Two of his attendant doctors died while treating him.

On January 4, 1877, the commodore said goodbye to members of his family. They all sang "Nearer My God, to Thee," and he passed away. No flowers or crêpe were ordered at the New York Central's railway stations, but the city hall flag flew at half mast, as well as those at the Manhattan and Union Clubs, where he used to play high-stakes whist.

There had been great speculation for years about the size of the commodore's fortune. Back in 1853, when he sold his lucrative "Gold Rush" steamship line to California and took a $500,000 cruise to Europe with twenty-three family members and friends on his brand-new, twenty-five-hundred-ton steamship yacht *North Star*, he had admitted to a fortune of $11 million.

Two years after that two-month European cruise, he announced that the Accessory Transportation Company was not meeting terms of the sale. Saying that "the law was too slow," he built a new steamship line and bankrupted the old one in just two years. He sold the new line in 1858, making $20 million, and then began speculating in railroad stock.

How Big a Fortune?

Speculation over his fortune increased when New York real estate magnate William Backhouse Astor Sr. died in 1875, leaving an estate of $40 million—the largest ever! Then, Alexander T. Stewart, the great department store magnate, died in 1876, leaving $40 million. In 1877, the commodore left an unheard-of $100 million.

Leaves $100 Million

Of the commodore's enormous fortune, $90 million went to William Henry to keep control of the railroads, with the rest divided unevenly among William Henry's four sons and the commodore's eight surviving daughters. Frank Crawford received his house, a pair of horses, a pick of harnesses and $500,000, while his undependable, gambling son, Cornelius Jeremiah, would get only the interest on $200,000.

Will Contested!

The public was treated two years later to a sensational trial when three of the daughters and Cornelius Jeremiah sued to overturn the will. The court, however, granted them only small additions to their bequests from what had been bequeathed to William Henry. Two spiritualist friends of the commodore, Victoria Woodhull and Tennessee Claflin, were subpoenaed to testify to his mental competence in making the will, but they sailed off to England just before the trial opened, and later both married wealthy Englishmen.

(7)

Anglesea

The next mansion, across the street and out on the point, is called Anglesea and was built by architect Detlef Lienau in 1880 for Walter H. Lewis, a dry goods merchant and a relative of Pierre Lorillard. In 1886, the year after Lorillard sold the Breakers to Vanderbilt and moved to Tuxedo Park, New York, Lewis sold this estate to Mr. and Mrs. Leslie Joseph Pearson.

Ayer's Sarsaparilla Popular

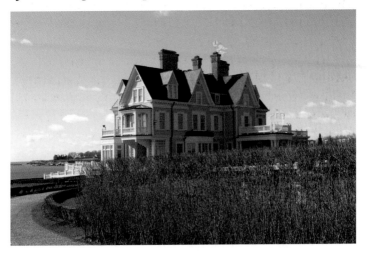

Anglesea.

Front gates of Anglesea.

Mrs. Pearson was the former Miss Ayer from Boston, of the Ayer's Patent Medicine family fortune. Ayer's Sarsaparilla was very popular, especially among New England farmers who didn't believe in alcohol; that is, until the Food and Drug Administration was founded in 1892.

At that time, the company had to start printing on the bottle what was in it. Everyone knew that whiskey was cheaper, and there was no longer any self deception when you drank it! But the business was reported to have already made $6 million.

One of the Pearson daughters married Beverly Bogard, and the Pearson-Bogard family held the property for one

hundred years. It was sold in 1996 to the Carpionato family of Providence for $800,000, according to the local press, and has now undergone extensive renovations.

Fairholme

Next door to Anglesea, the half-timbered, Tudor-style mansion Fairholme was built in 1870 by architects Frank Furness and Allen Evans for the Philadelphian Fairmont Rogers. Rogers is said to have once put his new gardener to the test in a very extravagant fashion. He had his footman spread an oriental carpet on the lawn and then told the gardener to reproduce the carpet pattern using plants.

Sunday Coaching Ritual

Rogers is credited with writing the authoritative book on the sport known as "coaching," which became very popular with gentlemen. In fact, the Sunday afternoon ritual for these Gilded Age socialites was for the entire family to dress up in their finery, climb aboard their coaches drawn by four to six horses and parade up and down Bellevue Avenue. Their coachmen were dressed in full livery, blowing their trumpets as they delivered calling cards at neighbors' mansions. No one was ever at home because they were all out doing the same thing.

View of Fairholme from the north at Ruggles Avenue.

For some years, Fairholme was owned by the Philadelphian banker John R. Drexel and later by Mr. and Mrs. Robert Young. Mrs. Young was the former Anita O'Keefe, sister of the American artist Georgia O'Keefe. Robert Young was one of three partners who, in 1954, finally succeeded in wresting control of the New York Central Railroad from the Vanderbilt families. By moving in across the street from the Breakers, he was making a social statement.

Duke and Duchess Visit

The Duke and Duchess of Windsor were numbered among the Youngs' guests, along with John F. Kennedy, who is said to have frequented their saltwater swimming pool.

Fairholme, though since considerably enlarged, was built in 1870—the year that Germany's Otto von Bismark

defeated Emperor Napoleon III and France's Second Empire—and gradually the Second Empire style of mansion and building design began to lose its popularity. (You will see, nonetheless, that Richard Morris Hunt used it during the 1870s, when he rebuilt Chateau Sur Mer. It is near the end of our tour.)

The year 1870 was also when the construction of the Brooklyn Bridge began. It was a year in which the New York Central moved more than seven million passengers and one million tons of freight into New York City. And just a year earlier, Jay Gould and Jim Fisk cornered the gold market in the United States, driving its price down from $163½ to $133 and causing a financial panic known as "Black Friday."

9

MidCliff and Honeysuckle Lodge

Continuing along Cliff Walk, both of the next two mansions, MidCliff (on your right) and Honeysuckle Lodge, were built in an asymmetrical Queen Anne style in 1886, the same year as the dedication of the Statue of Liberty. MidCliff's most famous owner was Pearl Mesta, President Truman's ambassador to Luxembourg and fundraiser par excellence

who was immortalized as the "Hostess with the Mostest" in the Broadway musical *Call Me Madam*.

Honeysuckle Lodge, built originally for Joseph M. Fiske, was later owned by the famous amateur golfer of the 1930s T. Suffern Tailer.

Belmont Beach

Continuing south on Cliff Walk and stepping on the large granite blocks on the beach, one can reach Marine Avenue at Belmont Beach. It was the scene of a rumrunner's smuggling disaster in 1925. When cornered offshore by the U.S. Coast Guard, the smugglers began jettisoning cases of Canadian whiskey, wrapped in burlap, in order to escape arrest. The cases washed up on shore days later during a storm.

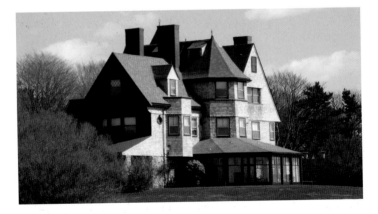

MidCliff.

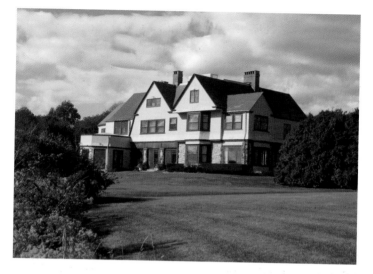

Honeysuckle Lodge.

The beach was soon packed with residents eager to salvage the cases. But when police arrived and roped off the area, they started confiscating the bottles, possibly making a good 100 percent profit on them later. Some residents are said to have waded into the cold water to enjoy a good drink before coming ashore.

At this stopping point, the tourist has several options for continuing the tour. If you continue south on Cliff Walk past Marine Avenue, you will find increasingly hazardous terrain and no exit for one and a half miles until you reach Ledge

Road. Views of the mansions are limited, as the walk sinks below eye level. For the experienced or adventurous hiker, however, this more challenging section of Cliff Walk affords spectacular ocean views. If you wish to continue and follow Cliff Walk to the access points at Ledge Road or Bailey's Beach, please turn to Section IV of this tour. If, instead, you wish to follow an alternate route on safer footing, follow the directions in Section III.

BELLEVUE AVENUE WALK

From Marine Avenue south to the end of Bellevue Avenue, this section is one mile long, not including the return trip back up Bellevue. From your stopping point on the Cliff Walk path, walk up a grassy hill to your right until you reach Marine Avenue. Follow this dirt road and you will pass MidCliff and Honeysuckle Lodge on your right, followed by Seaview Terrace. At the top of the hill, you will see the stone gates of Bythesea on your left. The mansion itself has been replaced by more modern houses, but the photo of the original Bythesea is included in this book.

Follow Marine Avenue to its intersection with Bellevue Avenue, then turn south on Bellevue and walk past the façades of Rosecliff, Astor's Beechwood, Marble House, Beaulieu, Clarendon Court, Miramar and Rough Point. Several of these houses are open to the public, including Rosecliff, Beechwood, Marble House and the Chinese Teahouse and Rough Point. Photos of the houses included in this book should help you identify which is which. Walking this stretch of Bellevue takes about half an hour, and there is a trolley service available that can take you back up the road and drop you off near Marine Avenue.

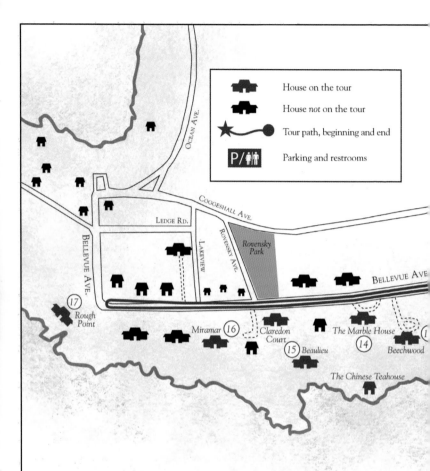

House on the tour

House *not* on the tour

Tour path, beginning and end

P/👫 Parking and restrooms

OCEAN AVE.

COGGESHALL AVE.

LEDGE RD.

BELLEVUE AVE.

LAKEVIEW

ROVENSKY AVE.

Rovensky Park

BELLEVUE AVE.

⑰ *Rough Point*

Miranar ⑯

Claredon Court

⑮ *Beaulieu*

The Marble House ⑭

⑬ *Beechwood*

The Chinese Teahouse

Section 3
Bellevue Avenue Walk

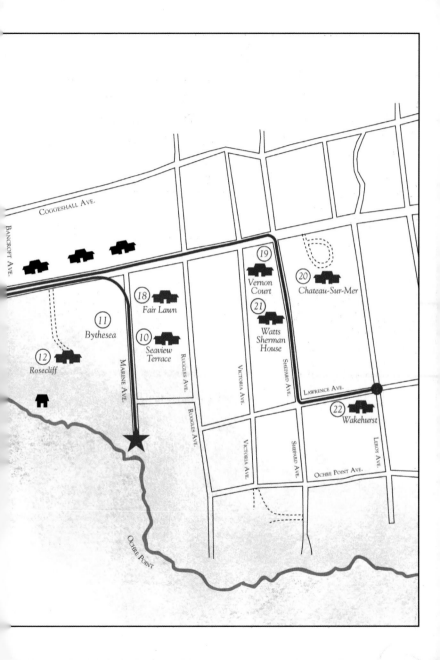

⑩

Seaview Terrace

Coming up on the right is Seaview Terrace. The French Norman Renaissance–style manor house was completed at a cost of $2 million just four years before the 1929 Wall Street Crash.

The fifty-four-room limestone mansion with forty bedrooms and twenty bathrooms was built by architect Howard Greenley for Edson Bradley, who made a fortune in mining and distilling. It also has a chapel, seating 150, which was built for Bradley's son-in-law, Bishop Shipman of New York. Shipman served as a chaplain at West Point and wrote the school's anthem, "The Corps."

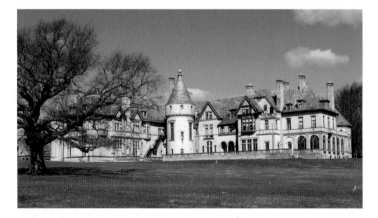

Seaview Terrace.

Later, the estate was bought by Martin Carey, brother of former New York governor Hugh Carey, as a headquarters for his oil company.

Dark Shadows *Film Set*

Carey's dream of finding oil off George's Bank never came true, and in 1949 he sold Seaview Terrace for a mere $8,000. (By the late 1960s, however, the mansion's value had climbed back up to $240,000.) In recent years, it has been leased by Salve Regina University as a dormitory. It also served as the stage setting for the movie thriller *Dark Shadows*.

(11) *Bythesea*

Continuing west along Marine Avenue and up a slight hill on the left side, you'll notice two great stone gates bearing the inscription "Bythesea." These gates were once an entrance to the estate, built in 1860 for Rothschild's bank agent August Belmont, who is often credited with starting the high society tradition of building summer cottages in Newport.

Bythesea was the first of a number of houses built in the so-called "vernacular" style by George Champlin Mason, who, as editor of the *Newport Mercury* weekly and reporter for Providence

The gates to Bythesea mark the spot where the mansion once stood.

and New York newspapers, teamed up with developer Alfred Smith in promoting this "Queen of Resorts" as the place where "the great ones of the earth" came to play.

Belmont had served the banking house of the Rothschilds in Frankfurt am Main, Germany, and Naples, Italy, before arriving in New York in 1837 to represent them at the young age of twenty-three. Within three years, he had not only already earned $100,000 for himself, but he was also considered one of the three most important private bankers in the United States.

Last Gentlemen's Duel

In 1841, Belmont was forced into a pistol duel with Edward Hayward in defense of a married lady's honor and walked

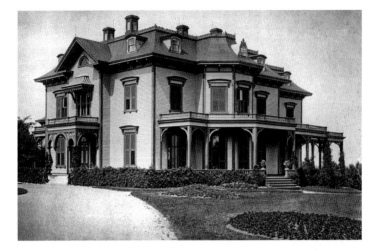

Bythesea mansion, no longer standing. *Courtesy of the Redwood Library.*

away with a silver bullet in his knee. It was once called the last gentlemen's duel in New York. Of course, today's New York businessmen continue to have duels, but they don't use silver bullets, and they certainly aren't gentlemen.

In 1849, Belmont married Caroline Perry, the daughter of Matthew Perry, whose treaty allowing American seamen to visit the port of Shimoda was an important first step in opening Japan to Western trade. Bythesea was one of the early large mansions in Newport, and Belmont was the first to introduce ten-course dinners with a staff of sixteen inside and ten outside dressed in full livery.

Caroline was the leader of New York society before Mrs. Astor arrived. Her hopes for her daughter Fredrika to succeed

This statue of Matthew Perry was made by John Quincy Adams Ward. It is now located in Newport's Touro Park near the Viking Mill on Bellevue Avenue, opposite the Griswold House (built by Richard Morris Hunt in 1862). That house now functions as the Newport Art Association's museum.

Mrs. Astor were dashed, however, when their third son, Oliver Hazard Perry Belmont, married Sarah Swan Whiting against their wishes.

Mother Moves into Bridal Suite

The newlyweds moved into the bridal suite on Paris's Champs Élysées, but the following day, Sarah's mother and two unmarried sisters moved in, too! Oliver couldn't get them out and ran off in a huff to Spain, where he was rumored to have taken up with a French lady.

The Belmonts' attempts to salvage the marriage failed, and in the subsequent divorce, they also lost custody of the couple's

unborn daughter. The girl was named Natica Caroline after Caroline Astor, her godmother, and not after her grandmother, Caroline Belmont.

August Belmont was a famous horse breeder, first and longtime president of the American Jockey Club—sponsor of the Belmont Cup—and national chairman of the Democratic Party, both before and after the Civil War. He died in 1890 at the age of seventy-seven.

This statue of August Belmont was made from a death mask some twenty years after he died by the noted sculptor John Quincy Adams Ward. It is now located in front of the headquarters building of the Preservation Society of Newport County at 424 Bellevue Avenue to commemorate his role in bringing high society to Newport.

(12)

Rosecliff

Rosecliff's Beautiful Proportions

Turn left from Marine onto Bellevue Avenue, and on the left you will see the gates of Rosecliff, which some claim—with its harmonious proportions—to be Newport's most beautiful house.

It was built of white-glazed terra cotta (to look like marble) between 1898 and 1902 by Stanford White for Mrs. Herman Oelrichs and her younger sister, Virginia Fair, both of whom played prominent roles in Newport (and New York) high society after Mrs. Astor retired to only giving tea parties.

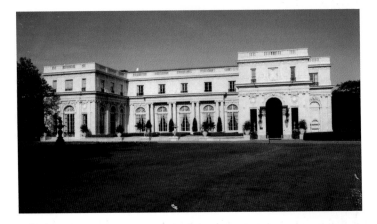

Rosecliff.

The H-shaped mansion, with its great French-style arched windows interspersed with Ionic half columns or pilasters, is modeled after the Grand Trianon, built as a garden retreat for Louis XIV by Jules Hardouin Mansart in 1690. Between the wings in the elongated bar of the H is the eighty- by forty-foot, Rococo-style ballroom with its ocean-view terrace on one side and a formal French-style parterre garden terrace on the other. The house is surrounded on all sides by extensive lawn vistas.

Insisted on Giving Parties

The $2.5 million mansion might have been completed much sooner had not Mrs. Oelrichs insisted, as early as 1900, on giving parties in it—she covered up unfinished areas with masses of flowers!

Great Gatsby Movie Set

You may already have seen parts of the interior, used as a stage set in the movies The Great Gatsby, with Robert Redford and Mia Farrow; The Betsy, with Sir Laurence Olivier, Katharine Ross and Robert Duvall; and True Lies, with Arnold Schwarzenegger.

Mrs. Oelrichs's husband, Herman, was the North American agent for the North German Lloyd shipping lines. He died of a heart attack on one of his ships only four years after the mansion was finished. Mrs. Oelrichs's sister Virginia, known

as Birdie, married William K. Vanderbilt Jr., the oldest son at Marble House, in a great matchmaking coup.

Society Matchmakers

The match was made by Mrs. Oelrichs with the help of the former "Tessie" (Theresa) Fair and Alva Vanderbilt-Belmont, who, along with Mamie Fish (Mrs. Stuyvesant Fish) of Crossways Mansion, had become known as the Great Triumvirate and succeeded Mrs. Caroline Astor in ruling high society.

These new society queens were very different birds of a feather than Mrs. Astor. Alva once accused Mamie of telling Tessie that she (Alva) looked like a frog (she was a little stout). Mamie said, "I never told Tessie you looked like a frog. I told her you looked like a toad!" With friends like that, who was worried about enemies?

$200 Million in Silver

Tessie and Birdie were daughters of James Fair, one of four Irish partners in the discovery of the Comstock Lode, or vein of silver, in Virginia City, Nevada—said to be the richest ever found in this country, worth eventually up to $200 million.

James Fair gave Tessie $1 million on her marriage to Herman Oelrichs but wasn't invited to the wedding because of his generally antisocial behavior and character. And because of his many wills and illicit affairs, Tessie went through years of legal battles to win the bulk of his estate after his death in 1894.

Developed the American Beauty Rose

Tessie and Birdie bought the original Rosecliff, a large wooden house, from the noted historian and diplomat George Bancroft in 1891 and demolished it to build the present structure. Bancroft, also a noted horticulturist, developed the American Beauty rose in large rose gardens here—hence the name Rosecliff.

Mrs. Oelrichs's new Rosecliff was later owned by J. Edgar Monroe of New Orleans, who made a fortune in sugar plantations and oil wells and later gave this property to the Preservation Society. It is now, along with Marble House and the Breakers, one of the seven major mansions open to the public.

While Stanford White was beginning work designing Rosecliff, he was also building the Gould Library on the Bronx Campus of New York University, which he completed in 1899 and which some critics consider his greatest work.

Architect Spots Spanish Dancer

A year later, in 1900, a new musical called *Floridora* opened at the Casino, at Broadway and Thirty-ninth Street, and there Stanford White first spotted actress Evelyn Nesbit playing the part of a Spanish dancer. White, in addition to being a great designer and party planner, had a reputation for secret liaisons with young actresses. He persuaded the mother of sixteen-year-old Evelyn to allow her daughter

to attend a luncheon at his Twenty-fourth Street hideaway apartment, along with three other girls. The luncheon grew into a five-year secret romance, until 1905, when Evelyn married the mentally erratic, wealthy playboy Harry Thaw from Pittsburgh.

After Evelyn returned with her husband from Europe in 1906, Stanford stupidly confided in a mutual friend that he intended to win back the affections of Evelyn, and to feed Harry's jealous temperament, Evelyn passed on this remark to Harry. It had the desired effect and then some!

Shots Fired on the Roof Garden

It was the evening of June 25, 1906, on the roof garden of the Madison Square Garden building, during the premiere performance of the musical *Mamzelle Champaign*, which Stanford had helped to finance. The tenor Harry Short had just sung the song "I Could Love a Thousand Girls" when Harry Thaw walked up to White's front table and shot him three times in the head.

An autopsy later indicated that the fifty-two-year-old White probably would have died within a year of Bright's disease of the kidneys and liver failure. But the two subsequent long murder trials of Harry Thaw were perhaps the most sensational in twentieth-century journalism.

President Teddy Roosevelt applied to his attorney general to see if he could stop newspapers from going through the mails to cities whose citizens did not wish to read such lurid

testimony, but he was told that he could not stop the "freedom of the press." When the *New York Herald* editors asked Bennett how to handle the Stanford White murder story, he wired back from Paris in traditional journalese, "Give him Hell!"

Thaw Escapes Insane Asylum

The first trial lasted three months and resulted in a hung jury; the second lasted only three weeks, with the verdict "innocent on grounds of insanity." Thaw spent eight years in a Long Island insane asylum until he escaped to Canada in 1913. Extradited back, he was released from the asylum in 1915 and pronounced "sane." Two years later, he kidnapped a nineteen-year-old youth and beat him unconscious in a New York hotel room. His mother rushed him back to an insane asylum, where he stayed for seven more years before he was once again released as "sane."

Harry Thaw died in 1947 in Miami Beach from a heart attack at the age of seventy-six. Evelyn died in 1967 at the age of eighty-two in a California nursing home, where she taught ceramics and sculpture following a checkered career as a dancer; running speakeasies in New York, Atlantic City and New Orleans; and writing two autobiographies. In 1955, she earned $50,000 as a consultant for the movie *The Girl in the Red Velvet Swing*, with actor Ray Milland playing Stanford White, Joan Collins as Evelyn and Farley Granger as Harry Thaw.

White Vilified as "Seducer"

Stanford White was vilified by the press in 1906 as a seducer and corrupter of young girls. *Vanity Fair* headlined its story: "Stanford White: Voluptuary and Pervert…Dies the Death of a Dog." Many of his old friends distanced themselves from him, including the *New York Herald* owner James Gordon Bennett, for whom Stanny had built, among others, the Veronese palazzo-style Herald Building on Herald Square in 1893. It had an arched colonnade with large glass windows revealing the presses rolling out as many as ninety thousand copies an hour.

On top of the building all along the roofline were twenty-six four-foot-tall bronze statues of owls—Bennett's favorite symbol—on three-foot-high pedestals, each with flashing electric light bulbs for eyes, symbolizing the wisdom going into the printed pages of the *New York Herald*. Also on the roof was a statue of Minerva, the goddess of wisdom, and below her a bell and two bell ringer figures, representing typesetters, who struck the bell on the hour with hammers and were known affectionately as "Stuff" and "Guff."

White's last architectural work—now gone, but which some critics call his greatest—was the new Madison Square Presbyterian Church, directly across the square from the old one where, in 1892, the Reverend Dr. Charles Parkhurst denounced former mayor Hugh Grant's administration as "administrative bloodhounds feasting off the ethical flesh and blood of our citizenship."

White's Unstintingly Praised Work

Though White had not cared much for Parkhurst, the fiery church leader unstintingly praised White's work on construction of the new church and lamented his death at the church dedication ceremonies. Three years later, in 1909, Stanford's beloved and faithful partner Charles McKim died at age sixty-two. The dependable third partner, the "Dummy" William Mead, carried on the work of the firm with new partners until his retirement in 1920. He died in 1928.

⑬ *Beechwood*

Next along Bellevue Avenue, the white house with yellow window trim is Beechwood House. Beechwood was built originally by architects Calvert Vaux and Andrew Jackson Downing in 1852 for a New York dry goods merchant, Daniel Parish. A year later, it caught fire and was rebuilt by Vaux. In 1881, Mrs. William Backhouse Astor Jr. bought Beechwood for $190,000 and called in Richard Morris Hunt for a $2 million renovation, including the addition of a ballroom holding four hundred. She also renovated her name, shortening Backhouse to just the initial "B" (at a time when outhouses were finally being phased out).

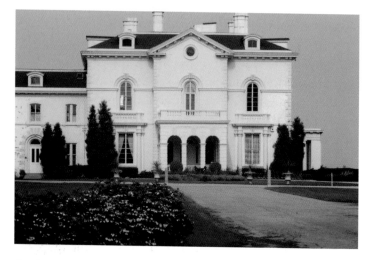

Beechwood.

With a slap in the face to Mary Astor (the rightful Mrs. Astor, who lived two houses down at Beaulieu), Caroline (Mrs. William Backhouse Astor Jr.) told her friends to address their letters to "The Mrs. Astor, Bellevue Avenue, Newport," creating a big headache for the postmen who had to decide whether deliveries should go to Beaulieu or Beechwood. The rather dumpy-looking Caroline, by force of personality, elaborate parties, costumes decorated with hundreds of diamonds (worn only in the evening) and the backing of the Patriarchs' Balls, finally triumphed over Mary.

"Take Off Your Boots, Man!"

The William Waldorf Astors moved to England and joined the British nobility as First Viscount Astor of Hever Castle. Their son Waldorf married the American Nancy Langhorne. Nancy became the first woman to serve in Parliament—and for all of twenty-five years. Her British election district included Plymouth. When one of her local farming constituents once tried to humiliate her by asking if she knew how many toes were on a pig's foot, she shot back: "Take off your boots, man, and count them yourself." She also had some famous verbal duels with Winston Churchill. Once, during a formal dinner party, Mrs. Astor quipped, "Sir, if I were married to you, I'd give you poison," to which Churchill instantly responded, "Madame, if I were married to you, I would drink it!"

Mrs. Astor Retires

Prince Louis of Battenberg was guest of honor at Caroline Astor's last great party in 1905 in her mansion at 840 Fifth Avenue, which Richard Morris Hunt had built for her ten years before. The following year, her ball was canceled because she had a fall on the stairs.

She spent the last three years of her life (she died in 1908 at age seventy-seven) as a senile recluse at Beechwood, the sixty-two-room mansion on Bellevue in the style of an Italianate villa.

(14)

Marble House and Chinese Teahouse

Behind the grand façade of Marble House and facing Cliff Walk sits the elegant, green copper–roofed Chinese Teahouse, built for social events and women's suffrage meetings in 1914 for Mrs. Alva Smith Vanderbilt Belmont by sons of the architect Richard Morris Hunt. Facing Bellevue Avenue, the $11 million Marble House was built by the elder Hunt in 1892 for William K. Vanderbilt, who had given it to Alva as a thirty-ninth birthday present.

But Alva divorced William three years later—after twenty years of marriage and three children—and one year after that she married Oliver Hazard Perry Belmont and moved into Belcourt, also a Hunt-designed mansion just a little farther south on Bellevue Avenue. Owned in recent years by the Tinney family, this Louis XIII–style mansion has been christened Belcourt Castle.

Oliver is reported to have given his castle to Alva as a wedding present, increasing her real estate holdings to two mansions. When Oliver died in 1908, he left his entire estate to Alva, and she moved back into Marble House and became a pioneer in the women's suffrage movement. She rented a large office building for them in New York City and bought them headquarters buildings not only in Washington, D.C., but also in Paris and Rome.

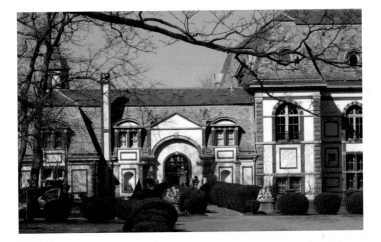

Belcourt Castle from the east side.

Gets Women "The Vote"

Also an early agitator, Alva led a parade of five thousand women down Fifth Avenue from Central Park to Washington Square on President Woodrow Wilson's inauguration day to make sure that she shared in the newspaper headlines. Just imagine what the grand dames of Newport thought about that! Once, when asked for guidance by a suffragette whom Alva was visiting in prison, Alva reportedly told her, "Pray to God: She will help you!"

Alva's next move was bolder still. In 1914, she invited two thousand guests down the sacred precincts of Bellevue Avenue to the palatial Marble House for a right-to-vote rally—letting every woman in free but charging every man two dollars. There were women in shirtwaists, women carrying umbrellas and paper bags, college women, countrywomen and giggling shopgirls.

The chief butler of her late second husband, Oliver Belmont, was in shock. Oliver had hired Azar while a young man in Egypt. To greet Oliver's guests at Belcourt, Azar dressed in a golden tunic and fez hat with an Egyptian-like tassel and was flanked by two English footmen dressed in full livery and silver-buckled shoes.

Walk a Dog on a String?

One day, Azar accompanied Alva on a train trip. When the train stopped, she asked him to take her French bulldog for a walk. "Madame," he said, "as a young man I was chief of camel drivers! I would rather leave my master's service than walk a dog on a string." In the Arab world, a dog was the lowest form of animal life. Azar did not walk that dog—perhaps the conductor did.

Governor Lost His Nerve

Alva was welcoming all classes of women to Marble House, and she invited Rhode Island governor Aram J. Pothier to address them. "How on earth shall I begin my speech?" he asked Alva.

"Vigorously, with 'Voters and Future Voters,'" she responded. Instead, however, the governor opened with a meek "Ladies and Gentlemen," followed by ten minutes of pleasant platitudes.

Next on the platform was an English militant suffragette, who boasted, "They say in London that I have the brains of

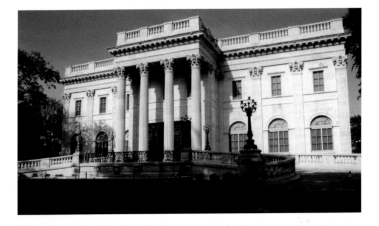

Marble House.

a man." Tapping her untidy head she said, "Well I should like to see the man whose brains I have." Poor Azar must have wished he was still driving camels.

After Congress passed the Nineteenth Amendment in 1920, Alva continued to work for women's rights until her death in 1933 at the age of eighty. She did not get her wish that female clergymen should conduct her funeral service in New York's St. Thomas Episcopal Church. Nonetheless, forty pallbearers, all representing women's rights organizations, were there to honor her, and they sang the women's rights hymn written by Alva herself: "No waiting at the Gates of Paradise, no tribunal of petty men to rule."

She Burned Her Portraits

Several artists, including Bellows and Sargent, had painted Alva in her younger years as a glamorous socialite. Shortly before her death, she succeeded in burning all the paintings, save one. She wanted to be remembered for her work for women's rights, not as the socialite she had been as a young woman. A copy of her remaining portrait now hangs on the hall wall as you enter the Marble House dining room. It shows Alva seated alone in the newly built Metropolitan Opera House, to which she was a major contributor. She had this portrait hung on the wall for her New York housewarming party of nearly twelve hundred guests so that everyone, especially young Carrie Astor, would recognize Alva's contribution to the Opera House.

Alva divorced her first husband, William K., on grounds of adultery, which he did not choose to contest. At the time, it was the only grounds on which a divorce could be granted in New York State, and a divorced woman was ostracized from society. But through sheer force of personality, Alva was probably the very first woman to maintain her social position after the divorce and into her next marriage with Belmont.

Arranges Daughter's Marriage

Alva did not grant her own daughter Consuelo such freedom of choice in marriage partners. Just before the divorce in 1895, both she and William K. forged an arranged marriage for eighteen-year-old Consuelo with the ten-years-older ninth Duke of Marlborough, Charles Spencer Churchill (first cousin of Winston Churchill). The wedding was scheduled for November and would take place in St. Thomas Episcopal Church.

Consuelo, who was secretly engaged to Winthrop Rutherford, wrote in her autobiography, *The Glitter and the Gold*, that her mother threatened to commit suicide and kept her imprisoned for six months in Marble House before her marriage.

Consuelo's marriage lasted thirty years, but half of it was in separation. Consuelo converted to Catholicism and married a French aviator, Jack Balsan, after Alva repented and testified before the ecclesiastical court in Rome that she had indeed forced her daughter, against her will, to marry the duke.

Winning Acceptance Took Time

In building Marble House in 1888–92, Alva worked very closely with architect Hunt, intending to make both a social and architectural statement, just as she had nine years before when she built her Fifth Avenue mansion and wormed her way onto Mrs. Astor's prestigious "400 list."

This time, Mrs. Astor herself is said to have told Alva that the land next to her own Bellevue Avenue mansion, Beechwood, was up for sale. That sounds like acceptance!

Alva had Hunt design Marble House after the Petit Trianon, which had been built as a garden retreat with a Greek temple front in 1764 by Ange-Jacques Gabriel on the grounds of the Versailles Palace for Madame de Pompadour. But Alva had Hunt add wings on each side with colossal two-story half columns to give the fifty-two-room mansion, which has only one guest bedroom, a grander appearance.

A Pack of "Administrative Bloodhounds"

The first housewarming party at Marble House was held on August 19, 1892. That was the same year in which the Reverend Dr. Charles Parkhurst delivered a thunderbolt from the pulpit of the New York City Madison Square Presbyterian Church to his startled congregation:

> *Every step we take, looking to the moral betterment of this city* [New York] *has been taken directly in the teeth of the damnable pack of administrative bloodhounds led by Mayor Hugh Grant, his Police Commission and his District Attorney's Office that are fattening themselves on the ethical flesh and blood of our citizenship!*

Though Parkhurst could not prove those charges before a jury, with the aid of a private detective he eventually found

evidence through personal visits. In 1894, the Senator Lexow Committee interviewed 678 witnesses in seventy-four separate sessions and reported that the charges of massive corruption in the city of New York were all true.

Teddy Enforces Blue Laws

The Lexow Committee's report was published in the *New York Times*. In the next 1894 election, the voters of New York rose up and elected honest Republican William Strong as their mayor. Strong named Teddy Roosevelt to head his new police commission, and together they tightened up the city's law enforcement, even closing bars on Sunday in accordance with the Blue Laws.

Reform mayor Strong also appointed Colonel George Waring as sanitation commissioner, and he introduced the modern system of refuse collection and street cleaning. What a difference!

Waring Bought Architect's House

Colonel Waring later bought the Newport house of Richard Morris Hunt, after it was moved from the site where the Viking Hotel now stands to nearby Greenough Place, where it stands today.

Unfortunately, the break in the long nineteenth-century rule of the Democratic Tammany Hall bosses was brief. Despite Boss Tweed's exposure and imprisonment in 1878 over the

Hunt rebuilt the original Greek Revival house into this form, now known as the Hypotenuse. It stood next to his own house, now the site of the Viking Hotel, but Hunt moved it a few blocks to 39 Catherine Street and sold it to George Waring, the street-cleaning engineer.

Teapot Dome scandal, Boss Kelley controlled Tammany from 1886 to 1902. Croker led Tammany to a Democratic victory in a bitter four-cornered mayoral campaign in 1897.

Mayor Strong's rule was short, but Teddy Roosevelt was later elected governor (1899–1900), then vice president and, still later, president of the United States from 1901 to 1909, after President William McKinley was shot by the anarchist Leon Czolgosz.

J.P. Morgan Reorganizes Steel

The year 1900 saw J.P. Morgan organize the U.S. Steel Corporation with capital of $1 billion. In 1901, he paid Andrew Carnegie $225 million for his share of Carnegie Steel, and in 1904, Tom Ryan and William C. Whitney (father of Harry Pane who married Gertrude Vanderbilt) recapitalized the American Tobacco Company at $180 million after an initial investment of $50,000.

Also in 1900, New York City's population passed the four million mark, and in that year, half of all government revenues were from customs duties collected by the Port of New York, according to the *New York Times*.

(15)

Beaulieu

Next along Bellevue Avenue is the Second Empire–style mansion Beaulieu (meaning "beautiful place") with its concave-shaped mansard roof built by architect Calvert Vaux in 1859 for the Peruvian ambassador Frederick L. de Barreda. It was also in the year 1859 that Charles Darwin published his *Origin of Species*, setting off religious and scientific controversies that are still bubbling today. And it was only one year before, in 1858, that Vaux and the famous landscape architect Frederick

Beaulieu.

Law Olmsted won the national competition to design New York City's great Central Park, which the city council, in 1853, had voted to establish.

Queen Victoria Sends Telegram

It was on August 16, 1858, that Britain's Queen Victoria and U.S. president James Buchanan exchanged telegraph messages, opening use of the first transatlantic cable. Fireworks celebrating that event the following day ignited the dome of New York City Hall. The city hall dome had to be rebuilt, and then on September 4, the first cable broke— so did the second one.

In November of that year, the Crystal Palace building, which had opened in Bryant Park in 1853, was also ignited by a fireworks celebration and burned to the ground—not a very good year after all.

But let's return to the forty-room mansion, Beaulieu. It was later owned by John Jacob Astor III and, after his wife Charlotte died in 1887, by his son, William Waldorf Astor Jr., who was married to Mary Dahlgren Paul.

Two Astors Claim Title

Mary had the right to the title of "The Mrs. Astor" over her aunt-in-law, Mrs. William Backhouse Astor Jr., who was married to the younger and less wealthy grandson of John Jacob Astor, the founder of the family fortune. It was J.J. Astor who had arrived in America with $25 in his pocket in 1784 and organized the fur trade in the northern United States and Canada and later in the Far East. He invested the proceeds in New York real estate that produced a $25 million fortune. That fortune was multiplied by his son, William Backhouse Sr., who branched out into New York tenements to house the city's exploding population of immigrants. In 1901, Mary's husband, William Waldorf Astor, sold Beaulieu to Cornelius Vanderbilt III, whose wife, Grace Wilson, continued to occupy Beaulieu for the next fifty-eight years.

Grace and Cornelius III also came into possession of his great-grandfather William Henry's Fifth Avenue mansion, and

she was determined to entertain every notable alive, especially if they were foreign nobility.

The Red Rose Inn

At her Fête des Roses party at Beaulieu in 1902, Grace brought in the entire cast of a Broadway hit, *The Red Rose Inn*, featuring its star (Stanford White's girlfriend) Evelyn Nesbit, to give a performance for her one hundred guests. On the grounds, she built a 275-foot midway decorated in turkey red calico and illuminated with red calcium lamps. She had gold and silver fireworks shot over the cliffs, and two orchestras played until her sunrise breakfast.

Her guest of honor, the Russian Grand Duke Boris, is said to have asked, "Is this really America or some enchanted isle. Such riches! It's like walking on gold."

Entertains German Nobles

In 1903, Grace entertained Germany's Kaiser Wilhelm on Cornelius III's yacht, also called *North Star*, in the Bay of Naples. But when, in 1914, she insisted on inviting the German ambassador, Count Johann-Heinrich Bernstorff, to a banquet party at Beaulieu, her husband, then a lieutenant colonel in the New York National Guard and with two English nephews fighting in France, refused to attend.

After the guests and the Prussian count arrived, the first course of soup was cleared without a hitch, but the second

course of fish failed to appear. Grace summoned the English butler Gerald to end the delay, but he did not return.

Everyone Spits in Soup

Finally, an Irish kitchen maid came in with a note on a silver tray. It said:

> *We regret to inform you, Madame, that we cannot any longer serve the enemy of our respective countries...we have thrown the dinner in the bin and have all left your service...after everyone of us carefully spit well into the soup.*

The staff returned the next day saying nothing, and Grace reportedly was also well advised to keep quiet.

(16)

Clarendon Court and Miramar

The next major mansions along Bellevue Avenue are Clarendon Court, built for Edward C. Knight in 1904, and Miramar, built for Mrs. George D. Widener in 1914.

Knight, whose family owned the Pullman Palace Car Company, named his mansion (also built in the French Beaux

Arts style by Trumbauer) after his wife, Clara. But when Claus Von Bulow owned the estate, he changed its name from Claradon to Clarendon Court.

George's father, P.A.B. Widener, made the family fortune from streetcars operating in Philadelphia, New York and Chicago. After George and his son Harry were drowned in the sinking of the *Titanic* in 1912, Mrs. Widener had Philadelphia architect Horace Trumbauer proceed with the plans for Miramar, as well as the Widener Memorial Library at Harvard University, both of which were built in their memory.

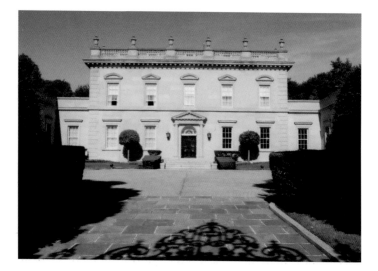

Clarendon Court.

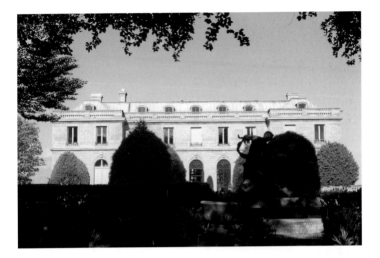

Miramar.

Architect Apprenticed at Age Sixteen

Trumbauer began his career at sixteen as an apprentice in the office of Philadelphia architects D.W. and G.W. Hewitt. Though, like Stanford White, he never received formal training in architectural schools, he designed the campus and many of the buildings at Duke University (called Trinity College before Duke's benefactions) in Durham, North Carolina. And before he built the Elms Mansion here on Bellevue in 1901 for coal magnate Edward Julius Berwind (a good friend of P.A.B. Widener), he had only built three other mansions as an independent architect—all in Pennsylvania, and one of them for Widener.

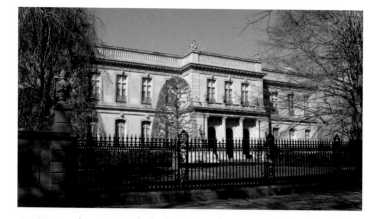

Trumbauer built the Elms Mansion, with its sumptuous sunken gardens and classical statues, in 1901 for the coal magnate Edward Julius Berwin. The house is on Bellevue Avenue.

Rough Point

Following Bellevue Avenue all the way to the point where it curves, the Tudor-style sandstone mansion that you see on the far left end is called Rough Point. The house was built by Boston architects Robert Peabody and Allen Stearns in 1891 for Frederick William Vanderbilt.

Later, Fred Vanderbilt also had architect Charles McKim build a large mansion for him at Hyde Park, New York, which is now open to the public. Fred, like his four sisters

and youngest brother, George Washington Vanderbilt, inherited only $10 million from his father, William Henry, while his older brothers, Cornelius II and William K., got the bulk of their father's $200 million fortune. Fred, however, was a brilliant financier and administrator, and he turned his $10 million legacy into $72 million on his own in banking and finance.

Fred's wife died before him, but his animosity toward other members of the Vanderbilt family was so great that he left nothing to any of them in his own will. Almost all of the $72 million was left to his wife's niece, Mrs. James Van Allen, who already had a fortune and lived at Wakehurst Mansion, which you will see last on this section of the tour.

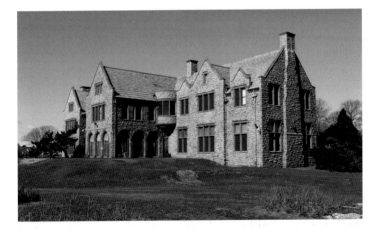

Rough Point.

View of the shore looking north.

Doris Duke Inherits

Rough Point was later purchased by James Buchanan Duke, founder with his brother of the American Tobacco Company, who on his death in 1925 left it to his daughter, Doris Duke. Doris later founded the Newport Restoration Foundation, credited with restoring some eighty-seven colonial-period houses in Newport, and she left an estate estimated at more than $1.2 billion. She died in 1992 at the age of eighty. The foundation has opened Rough Point for public tours.

Now that you have reached the end of Bellevue Avenue, you may want to catch a trolley for your return trip back to Marine Avenue. The yellow route #67 trolley will take you

up Bellevue Avenue. To see the last few houses on this section of the tour, get off the trolley at Marine Avenue. Should you decide to leave the tour and return to your car, the trolley can also drop you off at Narragansett Avenue, by the Forty Steps. For more information on trolleys, please visit the Newport Visitors' Center.

Once you have regained your starting point on Bellevue Avenue, walk northward to visit Fairlawn and Vernon Court, the next two stops on this part of the tour. Turning right from there onto Shepard Avenue, you will have views of Chateau Sur Mer on the left and the Watts Sherman House on the right. Walk east on Shepard Avenue and turn left onto Lawrence Avenue. Bearing immediately off on the sidewalk to the right, walk past a rose bed and continue on to the front of Wakehurst Mansion, concluding this section of the tour. If you then continue north some eight hundred feet and cut through a university parking lot, you will see Miley Hall and Ochre Court, where this section of the tour began.

18

Fairlawn

The Elizabethan-style manor house at the corner of Bellevue and Ruggles Avenues is called Fairlawn. It was built in 1852 for Andrew Ritchie by local contractor Seth Bradford but was

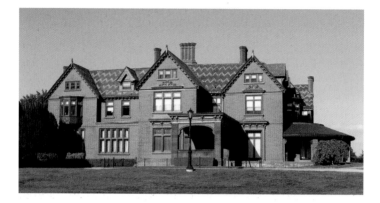

Fairlawn.

enlarged in 1869 by Richard Morris Hunt for Levi P. Morton, later vice president to Benjamin Harrison (1889–93). Legend has it that Eleanor Roosevelt had her "coming out in society" party at Fairlawn.

Early in this century, Fairlawn was bought by Townsend Burden, whose family fortune came from iron and New York politics. It was Mrs. Burden who is credited with introducing the court jester of later Gilded Age parties, Harry Lehr, to his first taste of high society in this house.

Impersonates the Czar

Lehr became a favorite prankster at the parties of Tessie Oelrichs, Alva Vanderbilt and Mamie Fish. Once, while Mamie and May Goelet were arguing, May refused to send

her houseguest, the Russian Grand Duke Boris, to Mamie's to be her guest of honor at Crossways. To lighten the embarrassment, Harry dressed up in a great cloak, with a chest full of medals and a crown on his head, and mimicked the duke, to the delight of Mamie's guests.

Mrs. Astor Approved Husband

Originally, it was Mrs. Astor who approved Harry Lehr as a spouse for the very wealthy Philadelphian Elizabeth Drexel. On their wedding night, however, Harry told his new wife that he had just married her for her money. He was brutally frank about his relationships with women, telling his wife, "Samson's strength lay in his hair…mine lies in the favor of women…All I have to do is keep in their good graces and everything comes to me."

He spent all his time in the company of women, listening to their secrets, advising them on their dresses and jewelry, their guest lists, wine lists, dinner entertainments, dance steps and erring husbands. He was no threat to any wives, however, and no threat to their husbands. "Do you imagine," he told Elizabeth, "that I am the type of man who would let himself be influenced by any woman's attractions, least of all yours? Let me tell you once and for all that love of women is a sealed book to me. I have not wanted it, nor sought it, and I never shall."

In public, Harry kept up the marriage façade for twenty-nine years, until he died of cancer, at which time Elizabeth married a prominent English gentleman, Lord Decies.

Excelled as a Matchmaker

Harry's father had a fluctuating fortune and died leaving Harry penniless at the age of seventeen. Before long, however, Harry's flattery, charm, humor and keen abilities for reading people caught the attention of Caroline Astor. Under her guidance, he became a successful matchmaker, bringing together Lord Waldorf Astor of Hever Castle and Nancy Langhorn. Lehr also set up the marriage of Robert Goelet's son to Elsie Whelen when she was staying at the Bellevue Avenue home of Benjamin Thaw.

Boasting of this match, Harry said:

> *I must say that I have a certain satisfaction at the thought of the Whelen wedding, which would never have taken place but for me. I always knew those Whelen girls would do brilliantly, and I think the marriage will be most suitable, for Elsie has both brains and beauty.*

Art Lessons and Immorality

The Goelet match was not as successful as Harry predicted—before long the couple was seeking a divorce. Elsie had begun studying painting with Henry Clews, of the less wealthy Rocks Mansion. Upon visiting the house, Mrs. Stuyvesant Fish commented, "Elsie tells me that they share the same naked man as a model…It doesn't sound at all proper to me, but I am sure it is."

When Elsie later obtained her divorce, no one was surprised when she married Henry Clews.

Common Folk: The Footstools

Harry Lehr had a snobbish habit of quoting the sayings of Louis XIV, France's seventeenth- and early eighteenth-century Sun King, in calling Newport's common folk "the footstools." He referred to Newport's Easton's Beach as "the common beach"—at the time, Bailey's Beach was the fashionably exclusive place to go, where watchmen in gold-laced uniforms protected its privacy from "the footstools."

Not Above the Law

Harry Lehr and his wife, Elizabeth, also played a crucial role in the wedding of Reggie Vanderbilt to his first bride, Cathleen Nielson. Reggie had been summoned by the New York police to appear as a state's witness regarding alleged irregularities in Richard Canfield's casino. The police raided the casino on the very night that Reggie had lost $150,000. Not wanting the bad press, Reggie tried to avoid the court summons, but the police were intent on showing that the Vanderbilts were not above the law. Plainclothes officers staked out the New York home of his fiancée, Cathleen, and spotted Reggie entering her house. An alarmed Cathleen called her resourceful friends Elizabeth and Harry Lehr for help.

Impersonates the Chef

On arrival, Harry rushed to the kitchen and dressed Reggie to look like the Nielsons' very stout Swedish chef. In this disguise, Reggie escaped the police undetected, avoiding the public ruckus that his court appearance would have entailed. Instead of having a big church wedding in New York, Reggie and Cathleen held their wedding at a more private location—Elizabeth Drexel Lehr's rented mansion, Arleigh, on Bellevue Avenue.

(19)

Vernon Court

The next mansion along Bellevue on the south corner of Shepard Avenue is called Vernon Court. It was built in 1901 for Mr. and Mrs. Richard Gambrill in the style of a French provincial chateau. Thomas Hastings of the architectural firm of Currier & Hastings was the builder of Vernon Court.

Mrs. Gambrill was the former Miss Van Ness, of the great Van Ness Harness Company, in Brooklyn, New York. Though the company was at one time quite successful, the invention of the automobile eventually totally eclipsed the manufacture of harnesses.

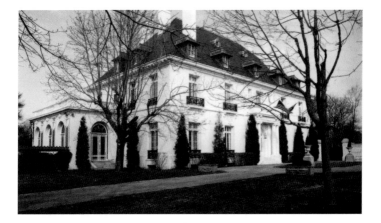

Vernon Court.

By Order of Henry VIII

The estate gardens, which have been replaced by tennis courts and a swimming pool, were created by Wadley and Smythe as a copy of those commissioned by Henry VIII for Anne Boleyn.

Wrote "Rock of Ages"

The builder of Vernon Court, Thomas Hastings, came from a rather well-known family. Hastings's grandfather wrote the famous hymn "Rock of Ages," his father was president of the Union Theological Seminary in New York and both he and John M. Currier were former draftsmen for McKim, Mead and White and former students at the École des Beaux Arts. While Hastings was building Vernon Court in 1901, he was

also designing the New York Public Library at Forty-first Street and Fifth Avenue, completed in 1911.

Today, Vernon Court houses the National Museum of American Illustration. It features original artworks by Norman Rockwell, Maxfield Parrish, N.C. Wyeth and many others.

A Naked Woman on the Church Door

In 1890, a controversy arose over another New York building—Trinity Church. In a contest to design a sculpture for the church's bronze doors, Richard Morris Hunt proposed a scene depicting "Adam and Eve Leaving Paradise." Rector Morgan Dix, however, had qualms about having a naked woman on the front entrance. In response to Dix's suggestion that Hunt pray over the matter, the architect shot back, "I'll be damned if I will!"

Stanford White, too, ran into objections to sculpting a woman nude in 1891, when he placed an eighteen-hundred-pound, 18-foot-tall, sheet-copper statue of the Greek goddess of the hunt, Diana—heavy breasted and completely in the buff—on the pinnacle of the 341-foot-high tower of his new Madison Square Garden building. Where children had previously played in the square below, they were now rushed past by parents or teachers. Pimply youths and balding men alike peered through binoculars, trying to get an eyeful.

White and his sculptor friend Augustus Saint-Gaudens decided that the statue's proportions were too large for the

341-foot tower, and in 1893 they replaced it with a svelte 13-foot-tall model of Diana. The statue inspired a story by the novelist O. Henry about the "Lady Higher Up" than even the Statue of Liberty in New York Harbor, which he derisively described as "Old Mother Hubbard."

(20)

Chateau Sur Mer

The next mansion on the opposite northeast corner of Shepard and Bellevue Avenues is Chateau Sur Mer, built of Fall River granite and designed in the style of an Italianate villa. The house was constructed in 1852 for William Shepard Wetmore, who retired to Newport with a fortune from selling mainly tea and silk in the China trade.

At the age of nineteen, William had gone to sea as a cabin boy aboard a China trade clipper ship to Canton, and on the homebound voyage the ship struck a reef off the coast of Chile. With partner Joseph Alsop in Valparaiso, William organized a salvage effort that was so successful, he ultimately became a China trade merchant himself. And because he refused to trade in opium, he found favor with some leading Chinese merchants, who ultimately helped him earn his fortune.

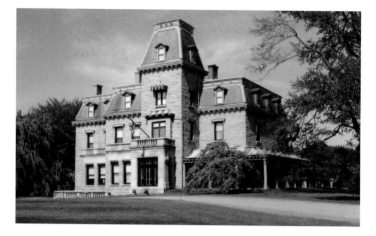

Chateau Sur Mer.

The Nine-Year Honeymoon

When William Wetmore died in 1862, he left the estate to his sixteen-year-old son, George, along with an allowance for his fourteen-year-old daughter, Annie. After obtaining two degrees from Yale University and a law degree from Columbia, George married into an old New York merchant family and went on a nine-year honeymoon tour of Europe. While he was away, he had Richard Morris Hunt transform the Italianate villa into a Second Empire–style French chateau with a mansard roof.

Since George was working for Morgan and Company in London, he couldn't have been honeymooning every day. On his return to the United States, he was twice elected as

governor of the state of Rhode Island and three times as U.S. senator from Rhode Island until 1913. During his eighteen years in the Senate, he is reported to have never introduced a single piece of legislation, but he always voted the right way.

The gatehouse in front and stables in back of the chateau are of brownstone and do not match the rest of the granite house. They were part of a brownstone mansion built by James Van Allen in 1848 that burned to the ground before it was ever occupied.

<div align="center">(21)</div>

Watts Sherman House

Turn right and continue down Shepard Avenue. The third building on the right, the William Watts Sherman House, is generally considered the first Queen Anne–style house in America. It was built between 1874 and 1876 by Henry Hobson Richardson and his two young apprentices, Stanford White and Charles McKim.

The style was named and popularized by a group of English architects headed by Richard Norman Shaw. Shaw's first English house in this style was called Leyese Wood, built in 1868. It featured a great central hall with an inglenook fireplace and multilanding staircase; an irregularly shaped exterior with multiple gables; cross gables; small-paned windows; first-floor

Watts Sherman House.

masonry walls with variant shingles; stucco; and half-timbered patterned walls above.

"Queen Anne" a Misnomer

The style was inspired by late English medieval elements from the Tudor and Jacobean period, so the popular name Queen Anne is really a misnomer. In fact, the Shingle style is really a derivative, and both were based on the development of balloon framing, or stud walls, in place of post-and-beam construction—which made it easy to build irregularly shaped buildings.

William Watts Sherman was a wealthy New York banker who married Anna Derby Whetmore. Her brother, George

Whetmore, gave them the land on which this house was built. Much of the design work on this multi-chimneyed house was done by Richardson's then twenty-year-old apprentice White, whom Sherman also called back in 1879 to rebuild the drawing room into a library, in Stanny's own inimitable style.

White Builds New York Metropolitan Club

Sherman also recommended White to build the New York Metropolitan Club in 1891, following an organizational dinner party where big shots like J.P. Morgan and William K. Vanderbilt expressed irritation with the old Union Club for rejecting some of their nominees for membership.

Rear view of the Watts Sherman House.

At the dinner, Sherman was named secretary and J.P. Morgan president of the new club, after which Morgan reportedly called White and told him, "Build a club for gentlemen. Damn the expense!" Incidentally, the building committee chairman was White's old client, Robert Goelet, for whom he had built Ochre Point Mansion.

White built the four-story Metropolitan Club at the corner of Fifth Avenue and Sixtieth Street, using Tuckahoe marble and an Italian Renaissance design. It was completed in 1894 at a cost of more than $2 million. As White was working on these masterpieces, some of Newport's famous architects were reaching the end of their careers. A year later, in 1895, the architect Richard Morris Hunt died, as did James Renwick and Calvert Vaux (who was found dead, an apparent suicide, floating on Gravesend Bay). Vaux's partner in designing New York's Central Park, Frederick Law Olmsted, died peacefully in 1903.

Newport Country Club

Newport's own Country Club was built in 1894 by Whitney Warren, a native Newporter who had returned the previous year from his studies at Paris's École des Beaux Arts. His design for the club was chosen out of the entries from seventy other architectural firms and impressed William K. Vanderbilt so much that he hired Warren in 1913 to build New York's Grand Central Station.

The club was founded by "Domino Sugar king" Theodore Havermeyer, who introduced the sport of golf to the town of Newport. A reporter sent to cover the first game at Brenton Point (on Ocean Drive) nicknamed the game "Cow Pasture Pool" because of the obstacles on the course.

Most gentlemen of "breeding" in the Gilded Age bred horses and belonged to New York and Newport coaching clubs, which enjoyed a system of ritual and etiquette of their own. Each coach had its own trumpeter, polished harnesses, sleekly groomed horses of chestnut, bay or black and coachmen in full livery. The ladies climbed on top of the coaches with a great display of lace petticoats. The tops of the coaches, one observer noted,

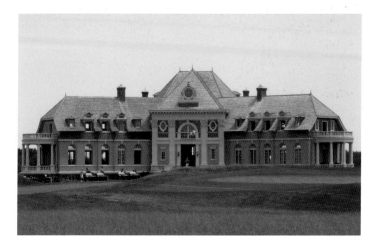

The Newport Country Club.

looked like so many flower gardens, for every woman had put on her most betrimmed hat and loveliest dress…painted parasols were unfurled to shield delicate complexions from the sun, and jeweled buckles sparkled on Paris-made shoes. Even the men succumbed to the gaiety of the occasion by wearing enormous bouquet buttonholes of red and white to brighten their regulation coaching livery of black coats, checked suits, tan aprons, and buckskin gloves.

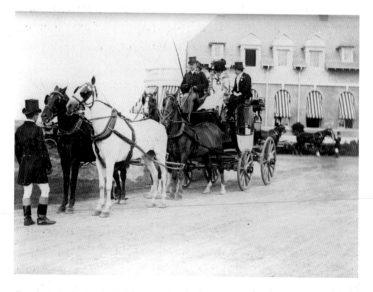

Carriage in front of the Newport Country Club. *Courtesy of the Redwood Library.*

Building Waldorf-Astoria

Around the time of the Newport Country Club's construction, architect Henry Hardenberg completed the 530-room, thirteen-story Waldorf Hotel on the site of the former Fifth Avenue and Thirty-third Street mansion of William Waldorf Astor, who had returned to England to join that country's aristocracy. In 1897, the $9 million, seventeen-story Astoria Hotel was completed next door, on the site of Mrs. Caroline Astor's former mansion ballroom, which had been designed for only four hundred. (She couldn't possibly have a mansion next to a hotel, even if it was owned by a relative!) Later, the two hotels were united as the Waldorf-Astoria.

(22) *Wakehurst*

Going left on Lawrence Avenue to the north of Shepard Avenue, you will find Wakehurst carriage house, owned by Salve Regina. Just to the north of that is the university's new $7 million McKillop Library, and past the library and rose garden is Wakehurst Mansion itself, now used as a student center. The mansion was built between 1882 and 1888 by local architect Dudley Newton and is a near copy of the English manor house Wakehurst Place, built in 1590 and now part of Kew Gardens in London. The landscape architect

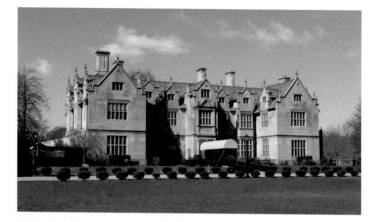

Wakehurst.

was Ernst Bowdich, who designed the Breakers grounds and those of several other Newport mansions.

Most Eligible Bachelor

Wakehurst was built for the Anglophile James J. Van Alen, a railroad heir who loved English furniture and sprinkled Shakespearean words into his daily conversations. Always using his English Tudor-style dialect, Van Alen's highest praise for a lovely lady would be: "A most delectable wench, forsooth!" His comment on an impertinent clerk: "Yon varlet insults us!" He married one of Mrs. Caroline Astor's daughters, Emily, who died young, leaving him one of the most eligible bachelors in Newport.

Once, upon issuing invitations to a musical concert for John Pierpont Morgan at Wakehurst, Van Alen incurred the wrath of society leaders Harry Lehr and Mamie Fish by excluding them from the invitation but including their spouses.

When confronted by Mrs. Fish at Bailey's Beach, Van Alen replied, carefully adjusting his monocle, "Very sorry my dear, upon my word, very sorry, but I can't have you and Harry Lehr at this party of mine. You make too much noise."

When Mamie Fish threatened to tell the society ladies that Van Alen's cook had smallpox and invite them all to a rival concert, Van Alen relented and sent Mamie an invitation. There was one condition, however—Harry and Mamie had to promise to stay on the terrace during the musical performance.

Van Alen had high hopes of becoming U.S. ambassador to Italy, but his dreams were dashed when Joseph Pullitzer's *New York World* published a scathing editorial about his life among the "Idle Rich."

Metropolitan Opera House

In 1883, the Metropolitan Opera House at Thirty-ninth and Broadway was dedicated, ending the Academy of Music's thirty-year run as New York's first successful opera house. The Met boasted 122 boxes (5 owned by William Henry Vanderbilt's family alone). These boxes held one-quarter of the 3,050-seat capacity. The Academy had 4,000

seats, but only a very small number of private boxes for the wealthy patrons.

The Met's boxes however, were notoriously drafty and were called "inadequate" for their poor views of the stage. The architect Josiah C. Cady audaciously boasted that he had never been inside an opera house before designing this one. Cady had won the commission to build the Met in a competition following construction of his much-admired design for the New York Museum of Natural History, dedicated in 1878.

Nevertheless, the Met provided eighty-three years of opera history before it was replaced by the new Met in Lincoln Center in 1965.

This concludes section III of the tour. Follow Lawrence Avenue north to return to Webster or Narragansett Avenue.

ADVENTURE WALK

If you choose to stay on Cliff Walk past Marine Avenue, be aware that the path becomes increasingly hazardous, unless you are a climber. From Marine Avenue, you will hike 1.5 miles along rocky terrain to the next available exit at Ledge Road, near the end of Bellevue Avenue. Keep in mind that almost none of the mansions along this section are visible from the Cliff Walk. You can only see them from Bellevue Avenue, and viewing them from that side requires only half an hour.

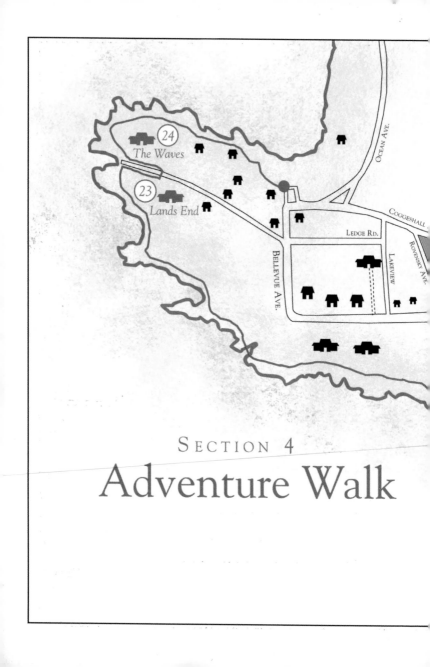

SECTION 4
Adventure Walk

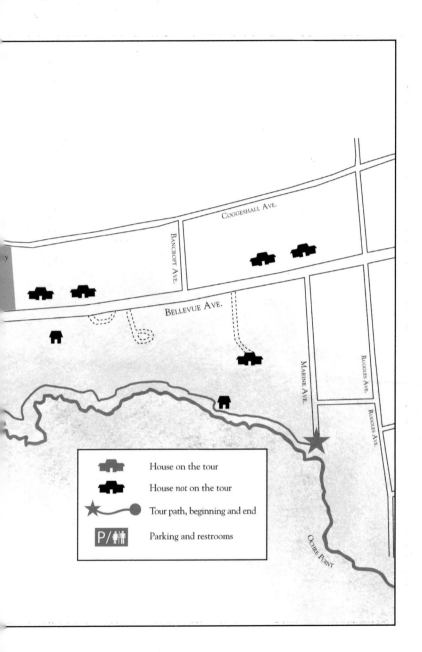

COGGESHALL AVE.

BANCROFT AVE.

BELLEVUE AVE.

MARINE AVE.

RUGGLES AVE.

RUGGLES AVE.

OCHRE POINT

House on the tour

House *not* on the tour

Tour path, beginning and end

P/🚻 Parking and restrooms

㉓
The Waves

On Ledge Road, on the southeast corner joining Cliff Walk, is the Waves Mansion, built first in the 1870s and known as Lippitt's Castle. It was rebuilt around 1927 by noted architect John Russell Pope, designer of the Jefferson Memorial and the National Gallery of Art in Washington, D.C. Pope's wife tried to block this section of Cliff Walk to public access but had to back down.

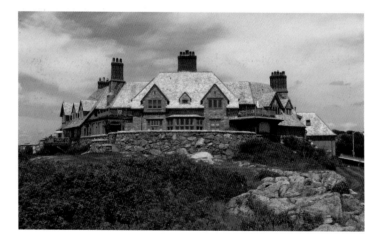

The Waves.

(24)

Lands' End

Going northward on Ledge Road, just a little farther on the east side is Lands' End, built by architect John Hubbard Sturgis for Samuel Ward in 1889. The house was later owned by the famous novelist Edith Wharton, who in 1893 engaged the artistic designer Ogden Codman Jr. to make significant alterations. Codman was also commissioned by Cornelius Vanderbilt II to decorate the bedrooms of his mansion, the

Lands' End.

Breakers. With Wharton, Codman published his famous revolutionary design book, *Hints on Household Taste*.

Should you decide while on Ledge Road that you want to follow Cliff Walk all the way to the end, go back to the south end of the street and turn right back onto Cliff Walk in front of the Waves Mansion. Past several more modest summer cottages, you will reach a public beach, locally nicknamed Reject Beach because you can use it if you've been rejected by the exclusive Bailey's Beach just to the west.

If you wish to return to Bellevue Avenue, the trolley line stops at this end of Cliff Walk during the summer months.

EPILOGUE

In his address at the opening of the 1892 Columbia Exhibition in Chicago, the famous New York political orator Chauncey M. Depew gave an elegant tribute to American architecture at the turn of the twentieth century. Praising the New York buildings designed by Hunt, White, McKim, Peabody, Vaux and Hastings, Depew called New York a "beacon of enlightenment and the birthplace of a new Renaissance." He spoke of 1892 as a

> *defining moment, when America's frontiers were closed, railroads had knit the nation together for the first time; natural resources of the immense land were feeding the factories and blast furnaces on a never-seen scale; the U.S. Navy's White Fleet had put to sea, and gleaming battleships hinted the U.S. was ready to join in Europe's imperial games.*

The United States had become a world power; its industries and wealthy families could match those of Europe; its

architects and artists strove to create a culture greater than Europe's; and Newport was the newly created summer colony of the new class of aristocrats and artists, building the new cultural utopia of their dreams. These mansions along Cliff Walk are truly the skeletal remains of those efforts. They are the cultural icons of that flowering of the American Industrial Revolution known as the Gilded Age.

BIBLIOGRAPHY

Baker, Paul. *Richard Morris Hunt*. Cambridge, MA: MIT Press, 1980.

————. *Stanny: The Gilded Life of Stanford White*. New York: The Free Press, Division of McMillan Inc., 1989.

Balsan, Consuelo Vanderbilt. *The Glitter and the Gold*. New York: Harper & Bros., n.d.

Black, David. *The King of Fifth Avenue: The Fortunes of August Belmont*. New York: Dial Press, 1981.

Downing, Antoinette, and Vincent Scully Jr. *The Architectural Heritage of Newport, RI, 1640–1915*. 2nd ed. New York: n.p., 1967.

Elliott, Maude Howe. *This Was My Newport*. Cambridge, MA: The Mythology Co., 1944.

Encyclopedia Britannica. Chicago: William Brenton, 1966.

Gilmartin, Gregory F. *Shaping the City: New York & Municipal Art Society*. New York: Clarkso Potter, Publishers, 1995.

Grafton, John. *New York in the 19th Century*. New York: Dover Publications, Inc., 1980.

Jefferys, C.P.B. *Newport: A Short History*. Portsmouth, RI: Hamilton Printing Co., 1992.

Lowe, David Garrard. *Stanford White's New York*. New York: Doubleday, 1992.

Lowenthal, Larry. "The Cliff Walk at Newport." *Newport History* (Publication of Newport Historical Society) 61, part 4, no. 212 (1988).

McAlester, Virginia, and Lee McAlester. *A Field Guide to American Houses*. New York: Alfred A. Knopf, 1984.

Patterson, Jerry. *The Vanderbilts*. New York: Harry N. Abrams, Inc., 1989.

Schumacher, Alan T. "The Newport Casino, Its History." *Newport History* (Publication of Newport Historical Society) 61, part 2, no. 206 (1987).

Silver, Nathan. *Lost City of New York*. New York: Wings Books, 1967.

Sinclair, David. *Dynasty: The Astors and Their Times*. New York: Beauford Books, 1984.

Tschirch, John. Preservation Society of Newport County Study Guides for The Breakers, Marble House, Rosecliff, Chateau Sur Mer, and The Elms. Newport, 1997.

Vanderbilt, Cornelius, Jr. *Queen of the Golden Age*. England: George Mann of Maidstone, 1956.

Webster's Biographical Dictionary. Springfield, MA: G&C Merriam Co., 1943.

Winslow, John G. "Winslow Oral History Project." *Newport History* (Publication of Newport Historical Society) 68, part 1, no. 234 (1997). Interviews with Daniel Snydacker Jr., executive director, Newport Historical Society.

Wurman, Richard Saul. *The Newport Guide*. Newport, RI: The Initial Press Syndicate, n.d.

ABOUT THE AUTHOR

Ed Morris is a veteran reporter for two Connecticut newspapers and was a correspondent for the United Press International's Berlin Bureau just before the construction of the Berlin Wall by Communist East Germany. In developing this book as a basis for the Newport Historical Society's guided tours of Cliff Walk, he has made extensive use of the society's research facilities, printed reports and many other sources, but the responsibility for the material contained herein is his own. A graduate of Wesleyan University in Middletown, Connecticut, he has also served as a tour guide for several Newport historical organizations for many years.

Visit us at
www.historypress.net.

For guided tours of Cliff Walk, call the Newport Visitors'
Center at 401.849.8048 or visit cliffwalktour@aol.com.